THE FASHION DESIGNER'S DOODLE SKETCHBOOK

Carolyn Scrace

BOOK HOUSE
a SALARIYA *imprint*

D0257190

PAPER FROM
SUSTAINABLE
FORESTS

SALARIYA

Published in Great Britain in MMXIII by
Book House, an imprint of
The Salariya Book Company Ltd
25 Marlborough Place, Brighton BN1 1UB
www.salariya.com
www.book-house.co.uk

PB ISBN-13: 978-1-908177-52-0

3 5 7 9 8 6 4 2

A CIP catalogue record for this book is available
from the British Library.

Printed and bound in China.

Reprinted in MMXV.

Be bold!
Be daring!
Be spontaneous!

Introduction

It's up to you how you interpret and embellish the drawings in *The Fashion Designer's Doodle Sketchbook.*

Rules

The only rules are that you must be creative, spontaneous, daring and bold. The only essentials are that you have fun and thoroughly enjoy yourself while using it!

Notes

Alongside the drawings are brief notes with suggestions to help you get started. Choose a theme for each outfit — Highland Queen, for example.

Colour

Choose your colour scheme: russet, ruby red, chestnut brown and olive green.

Layer red lace with leopard print fur...

Feather

Highland Queen

Fake fur

Lace

Tartan

COLOUR

Use the colour charts below for inspiration. First decide on your palette (choice of colours). Try combining colours that harmonise, or experiment with colours that clash. The colours you pick can be pale, muted, vivid, rich, dark, sombre or electric! See how your use of colour can create different emotions.

Inspired by Byzantine mosaics? Choose golden yellows, with vibrant blues and purples.

Before you draw on top of a shape or add pattern, wait for the first colour to dry, so it doesn't smudge.

Colour

Colourful designs

Pencil crayons are easy to use. Try layering the colours and using different shading techniques. Make notes of exciting colour combinations so you can use them again.

Hard as nails

Light blue on violet

Mid-blue on purple

Try mixing different media, such as paper collage or wax crayons with watercolour. Try using felt-tip pens, coloured inks and gouache. Be adventurous and creative — discover what materials work best for you!

TECHNIQUES AND MEDIA

Many of the fashion drawings in this book were done with a dip pen and ink. Dip pen nibs can create a wide variety of lines, from thin and scratchy to bold and sweeping.

Dip pen and ink

Cross-hatching

Ballpoint pen

Cross-hatching is a useful technique to produce tone and texture in an ink drawing. Start by drawing rows of parallel hatching lines. Build up criss-crossed layers of hatching to gradually darken your tones. Try using this technique with ballpoint pen instead of dip pen and ink.

Use finger-printing to create texture or to darken tones.

Brush and ink

Drawing with a brush and ink creates a softer, bolder effect. Try to keep the lines simple, fluid and minimal.

Finger-printing

Watercolour paints

Pencil crayons

Layer darker colours on top of lighter ones to produce richer tones and added texture.

Wax crayons

Sponging

Dip a scrap of sponge (or tissue) in some paint or ink and dab on the colour to create instant texture.

Wax crayons and watercolours

Draw a pattern in pale-coloured wax crayon, then colour over with watercolour paint.

Felt-tip pens

Sketch in a very short kilt, add a sporran with long tassels. Then use a dip pen and ink to draw them in.

Fabric samples can be very inspiring. Here the chosen theme is Scotland, teaming up vivid red tartan with lace.

Experiment with different patterns and colour schemes.

Use pencil crayons to colour in the hat, feather, brooch and sporran. Try using a mixture of media to convey the different textures of the fabrics. Pastels are soft and can be smudged to produce the effect of fur. Layer wax crayon and watercolour to create interesting textile patterns.

Add a zigzag shape around the hem. Pencil crayons were used here to colour in the different tartans on the kilt and the skirt.

A scribble pattern using a pencil crayon is an easy way of achieving a lace effect.

Or let your mind go free and use it as a colouring book.

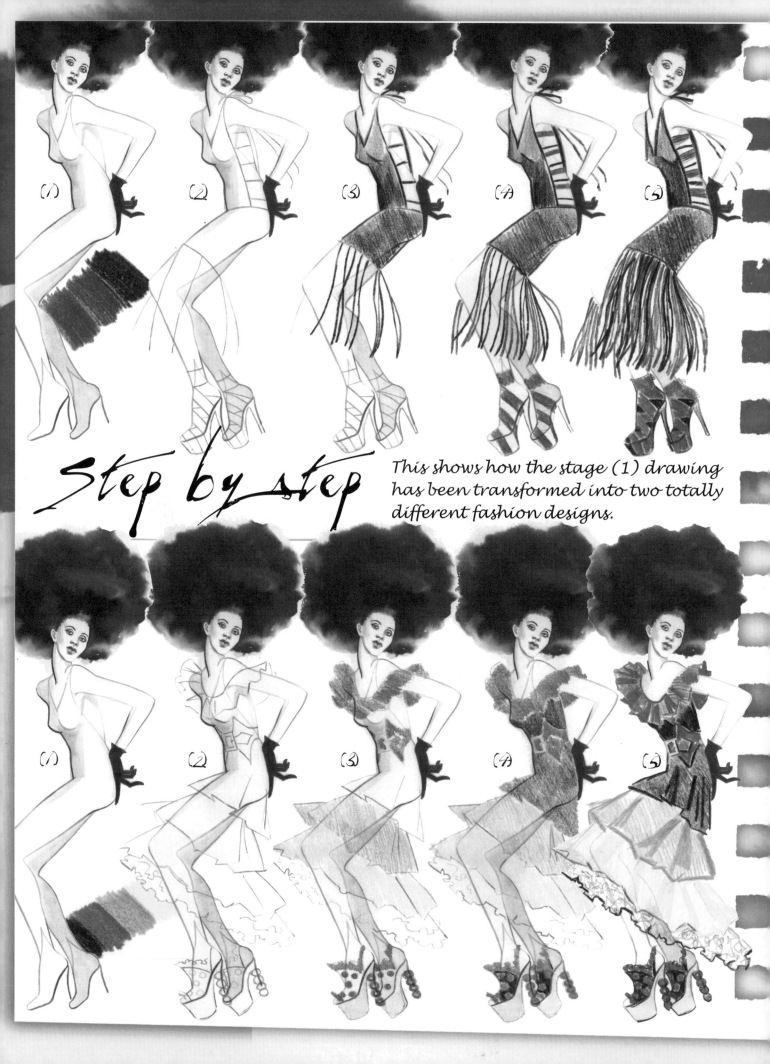

step by step

This shows how the stage (1) drawing has been transformed into two totally different fashion designs.

Imagination

Let nature inspire you. Try leopard-print patterns juxtaposed with diamante trim!

Crazy colour

Leopard spots

Sun motif...

Black, tan and cherry!

Sunshine yellow with rich, tropical sky blue.

DRAWING

Use a soft graphite pencil for your initial sketches.

To create your own fashion drawings, start by sketching in the basic shape of the figure. Choose a graceful pose, and elongate your model: lengthening the legs, arms, body and neck always makes clothes look more elegant.

Add more detail to the face. Simplify the neckline.

This finished drawing was done using brush and ink.

Concentrate on the principal features of the outfit — in this case the headdress and shoulders.

Ink in using bold, strong lines. Erase any pencil lines.

Try different tonal combinations — a light or dark-coloured dress.

POSES

Fashion magazines are a good source for poses. Choose a pose that shows off the clothes to their best advantage.

Exaggerate the hip shape or the line of a dress or hat. Remember, these are fashion designs and not realistic drawings.

Look at all aspects of the style. The make-up, hairstyle and accessories you choose should compliment the design of the clothes.

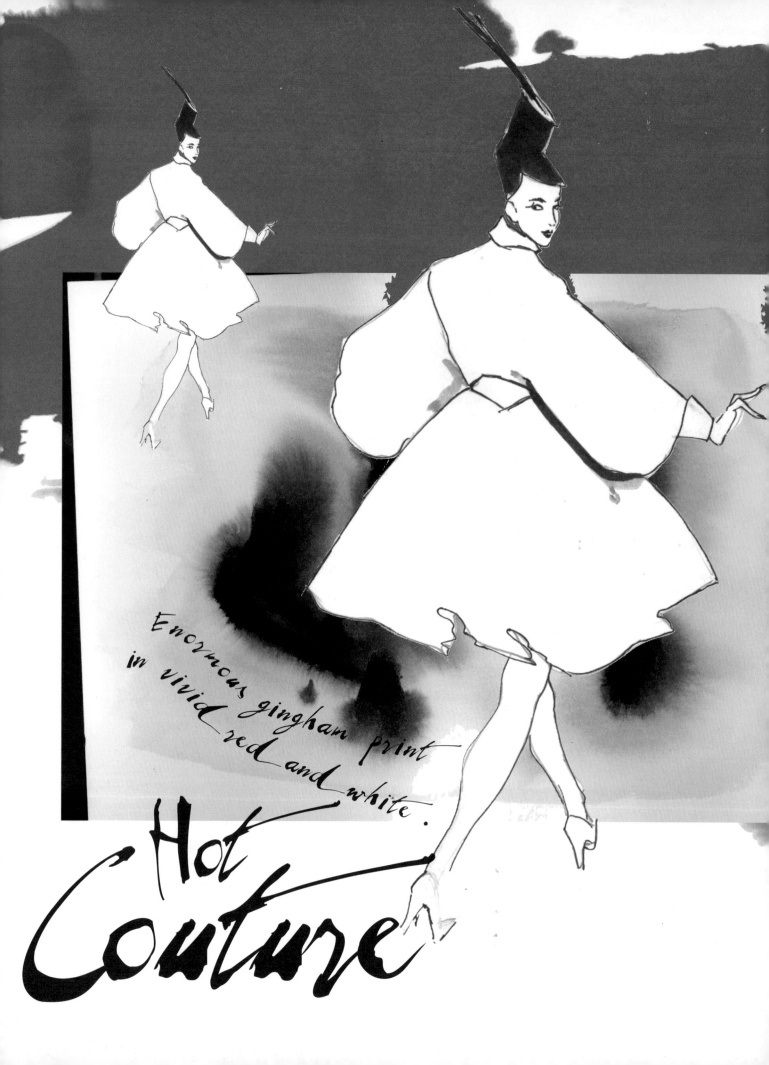

Enormous gingham print in vivid red and white.

Hot Couture

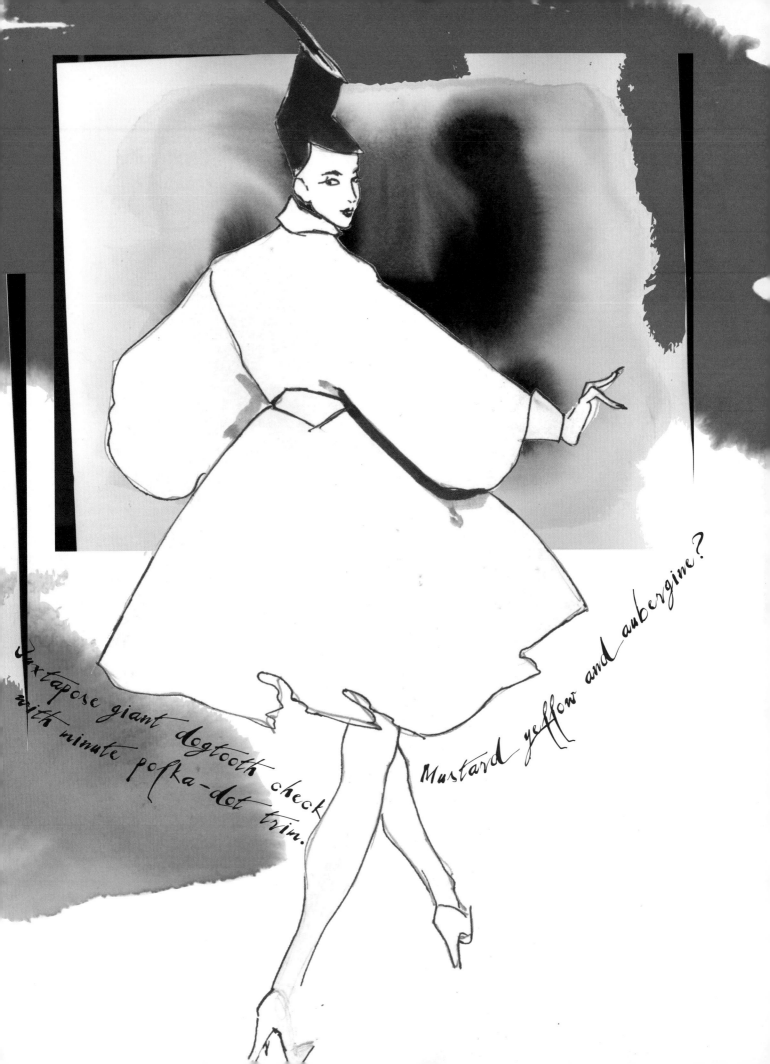

Juxtapose giant dogtooth check with minute polka-dot trim.

Mustard yellow and aubergine?

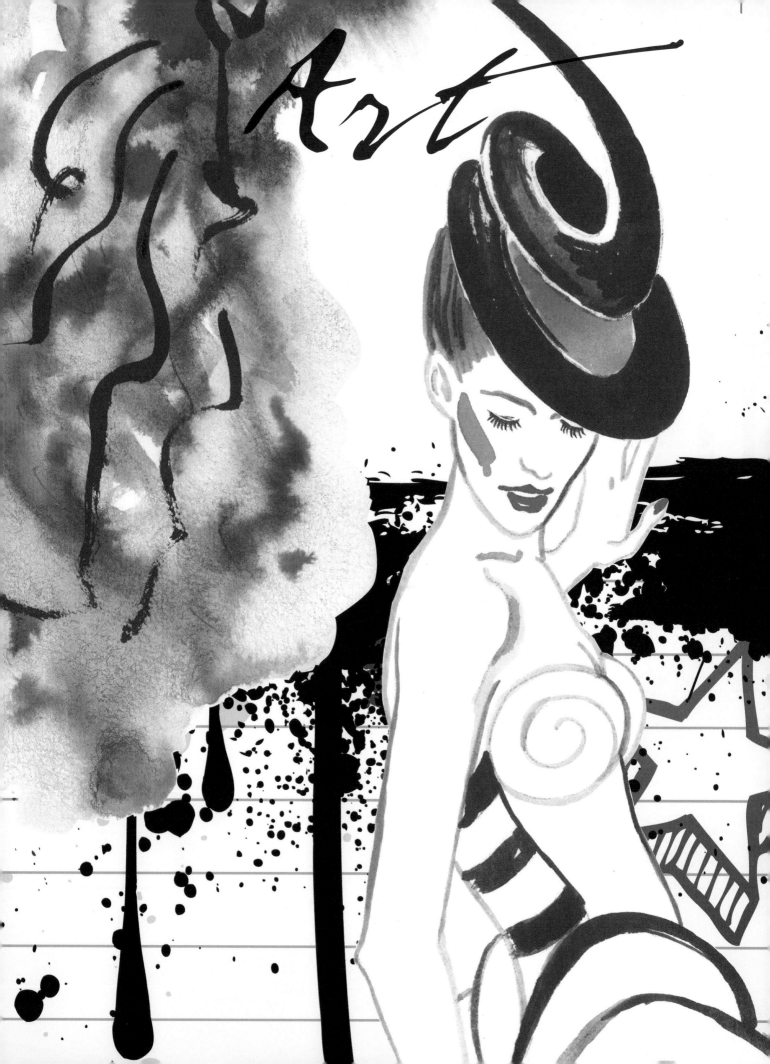

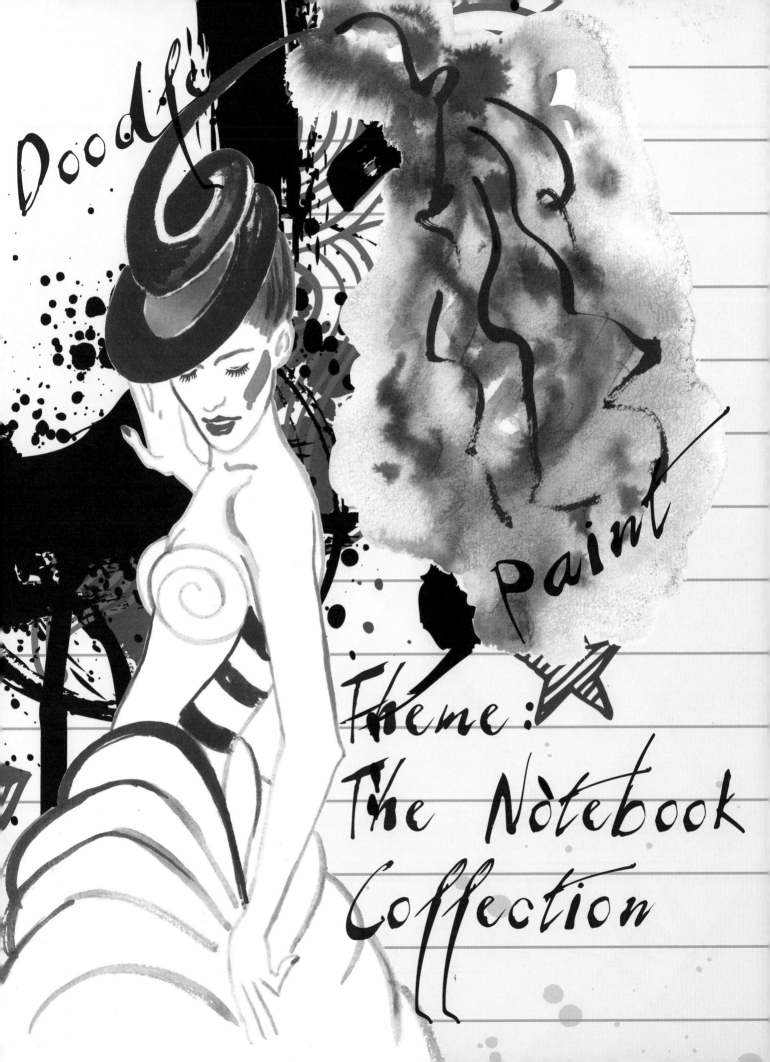

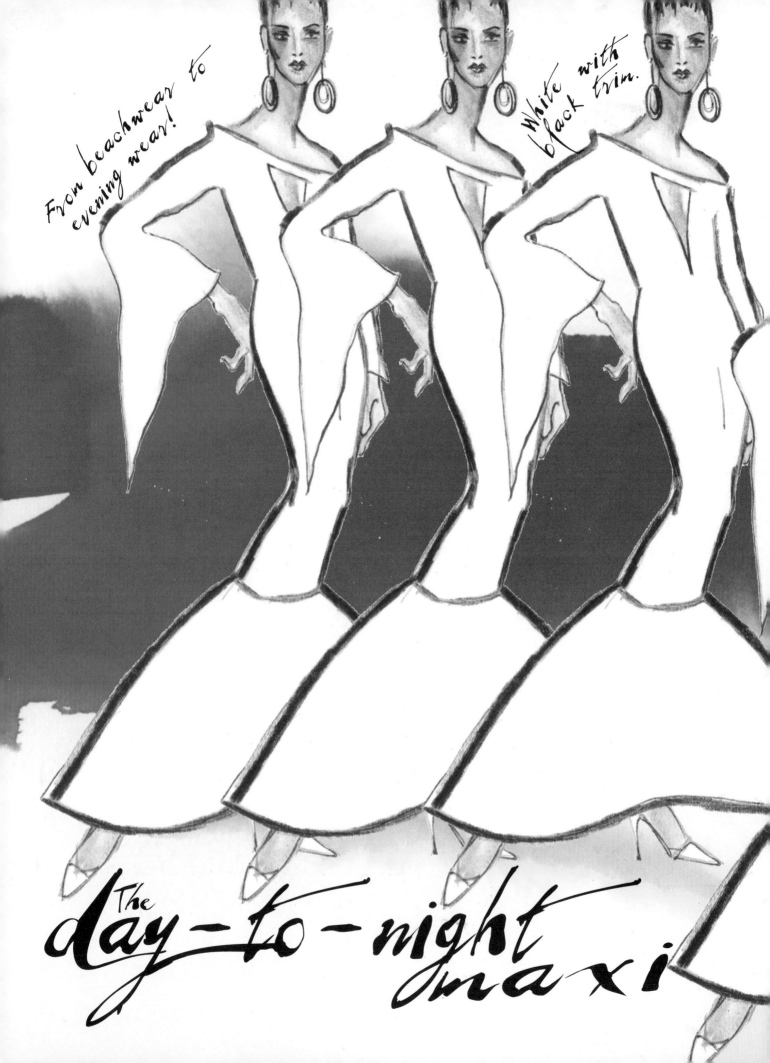

From beachwear to evening wear!

White with black trim.

The day-to-night maxi

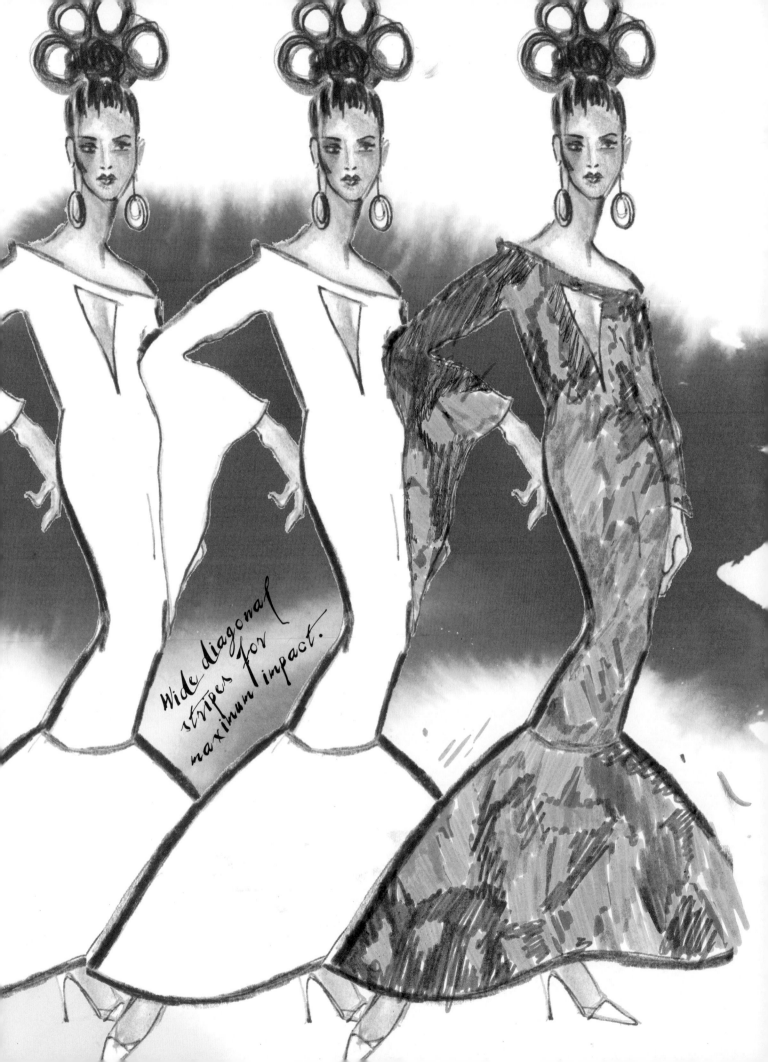

Wide diagonal stripes for maximum impact.

Glamorous

Electric-blue eye-shadow smudged above and below the eye.

Dramatic blood-red eyebrows!

Tangerine blusher.

Rich coral-pink lips.

Moss-green lids, merging into dark purple, blending outwards to soft lilac.

Retro, black batwing-shaped eyeliner. Whispy, cat-like false lashes embellished with rhinestones!

Matt purple lips.

Make-up for the evening...

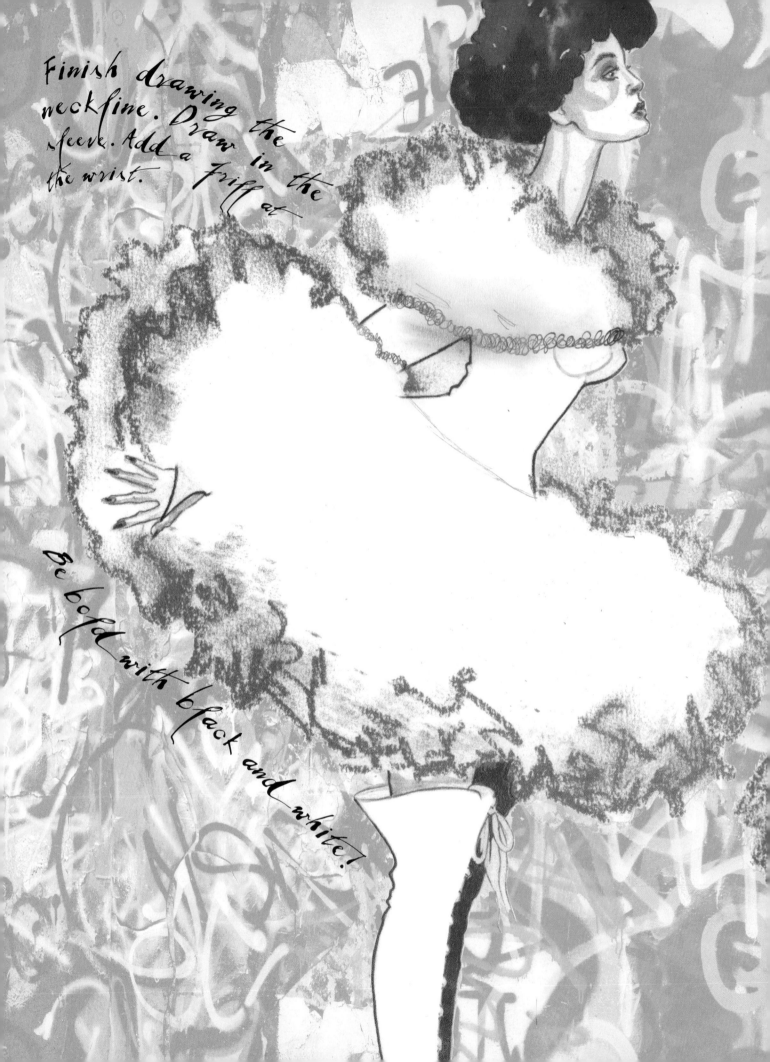

Finish drawing the
neckline. Draw in the
sleeve. Add a frill at
the wrist.

Be bold with black and white!

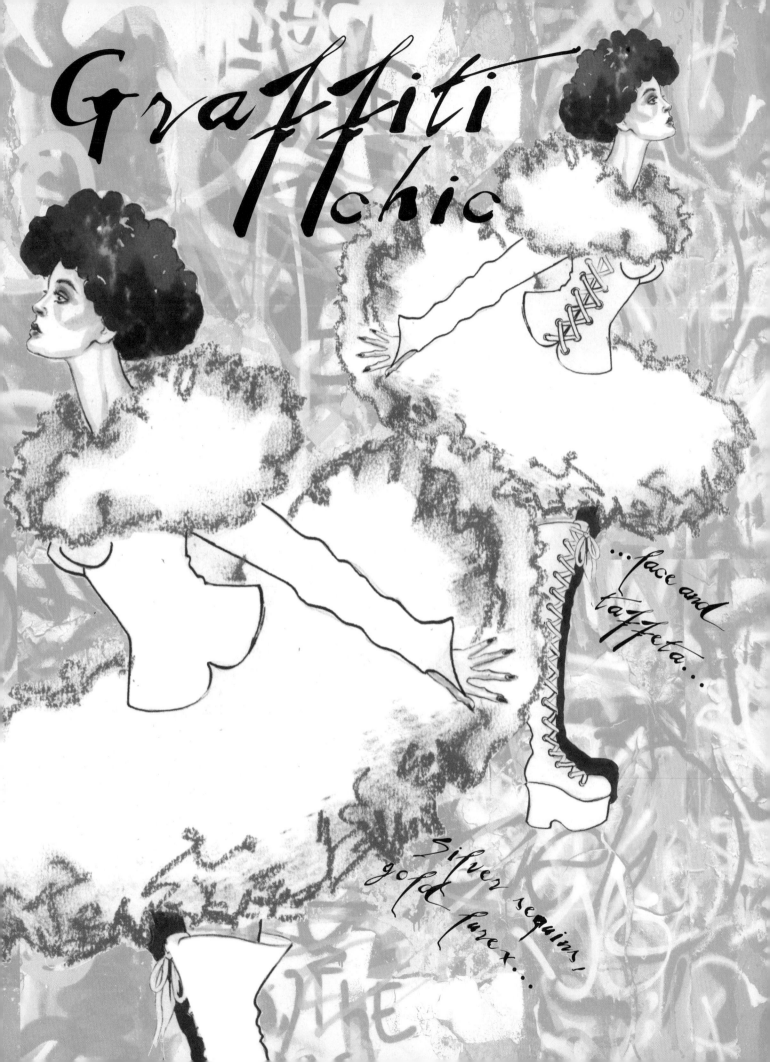

Graffiti Chic

...lace and taffeta...

Silver sequins, gold lurex...

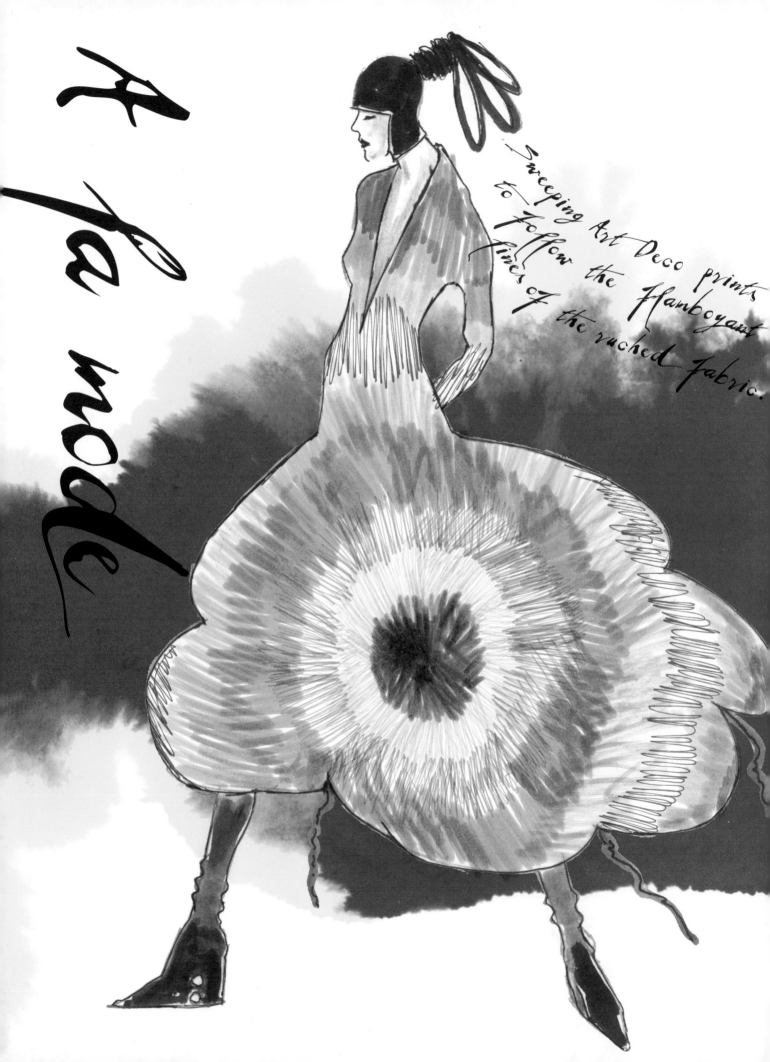

À la mode

Sweeping Art Deco prints to follow the flamboyant lines of the ruched fabric.

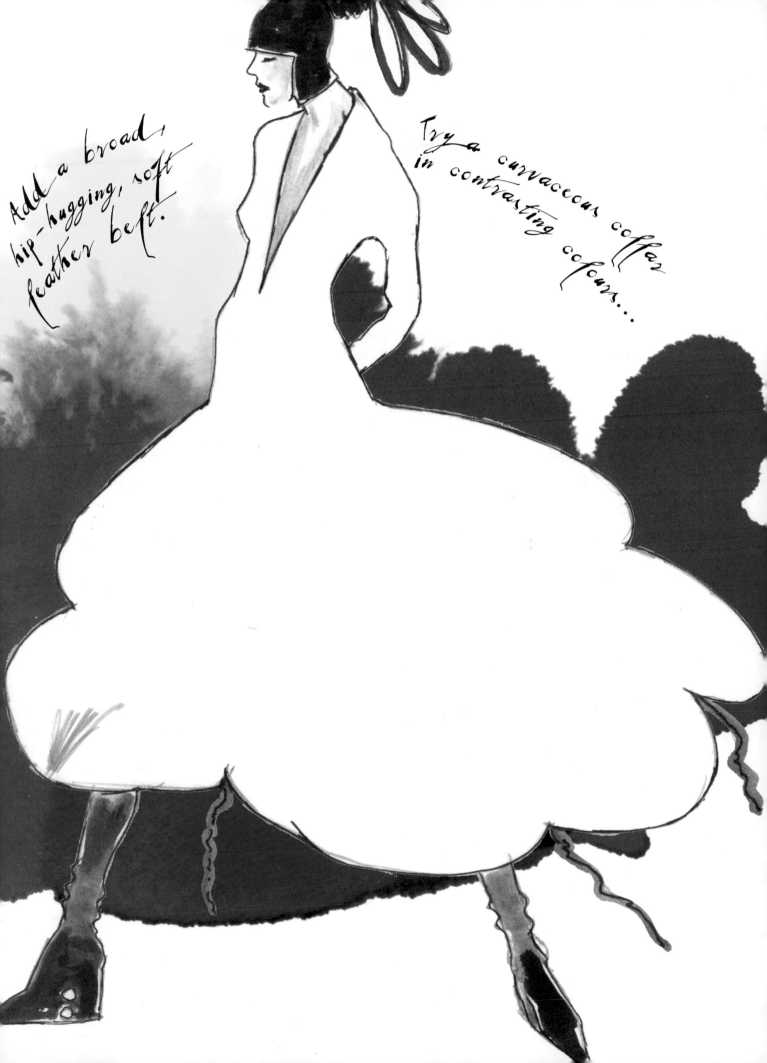

Add a broad, hip-hugging, soft feather belt.

Try a curvaceous collar in contrasting colours...

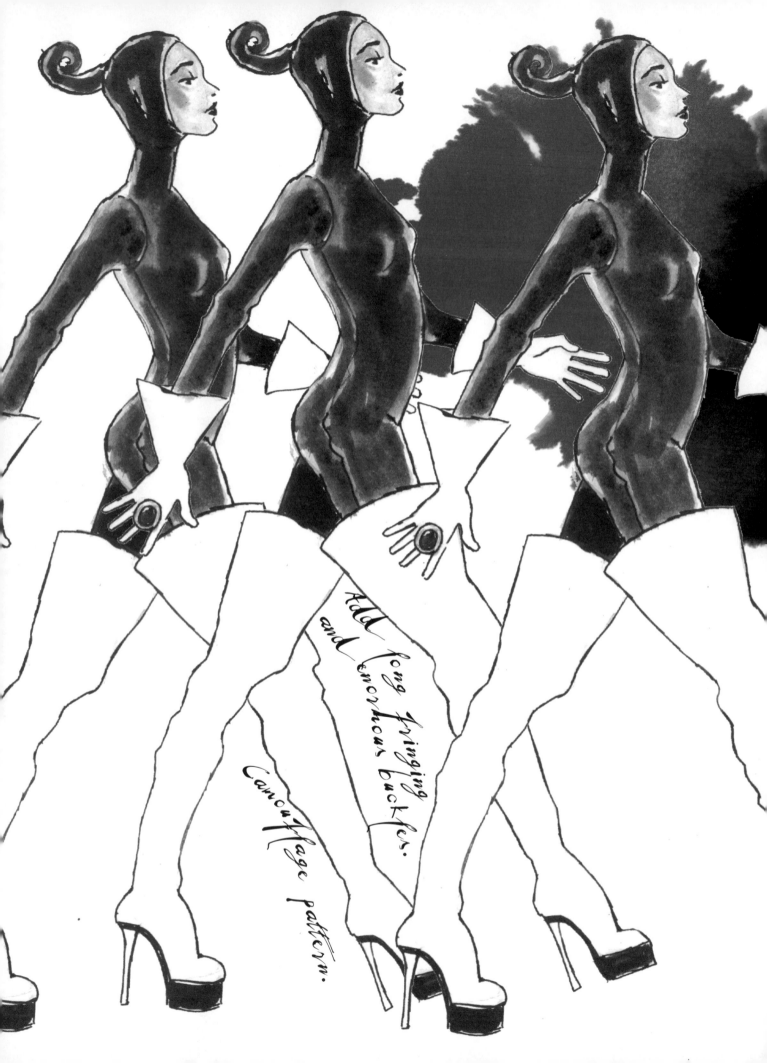

Add long fringing and enormous buckles.

Camouflage pattern.

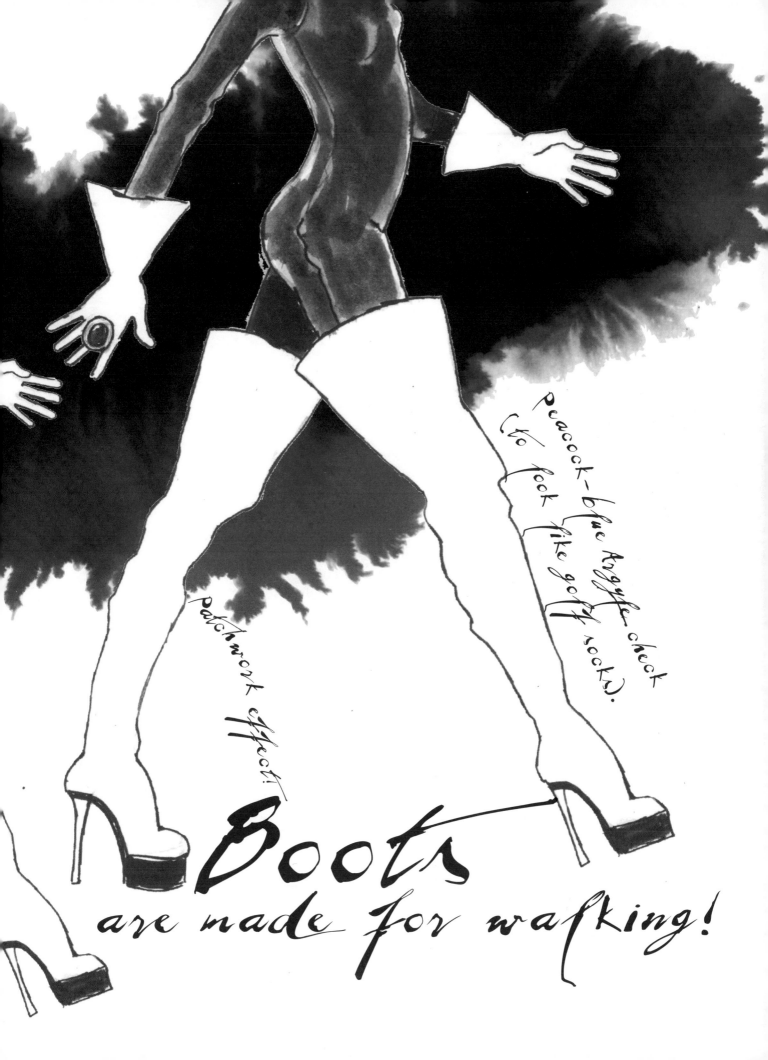

Peacock-blue Argyle check (to look like golf socks).

Patchwork effect!

Boots
are made for walking!

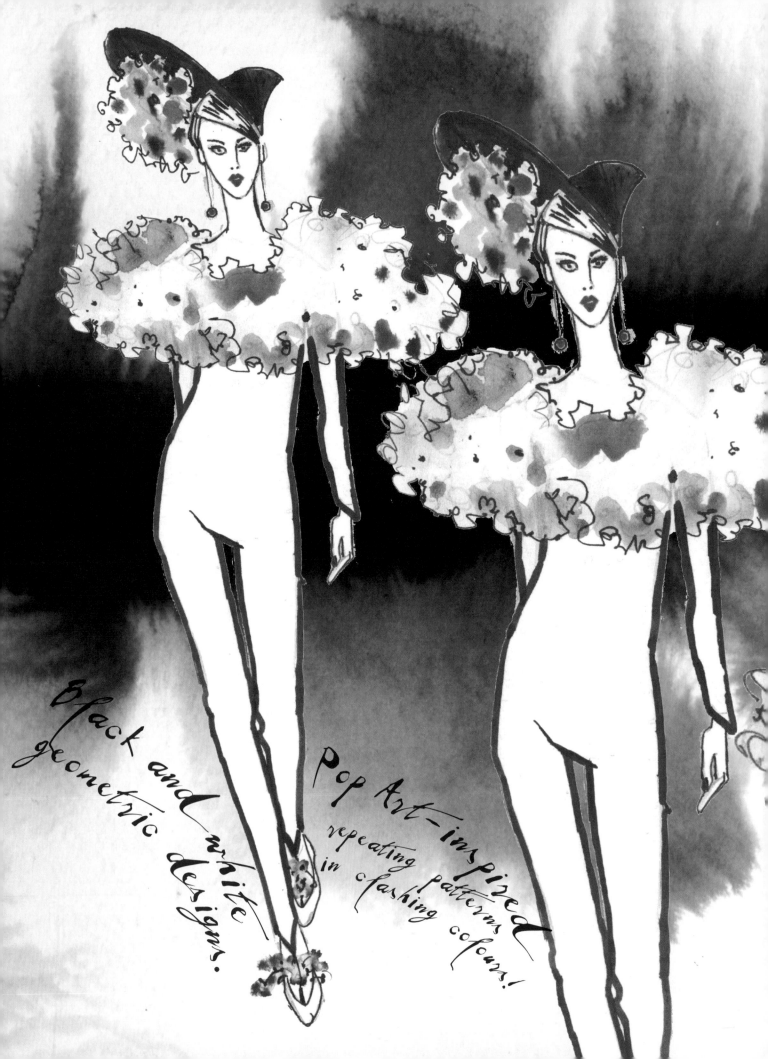

Black and white geometric designs.

Pop Art-inspired repeating patterns in clashing colours!

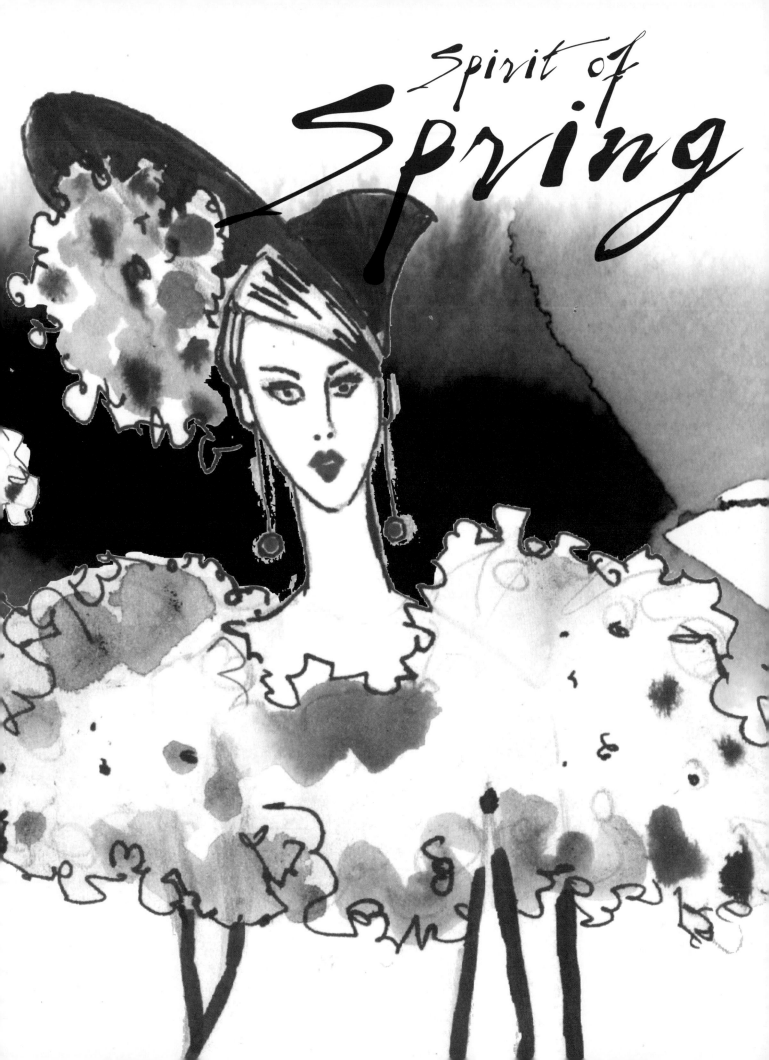

Spirit of Spring

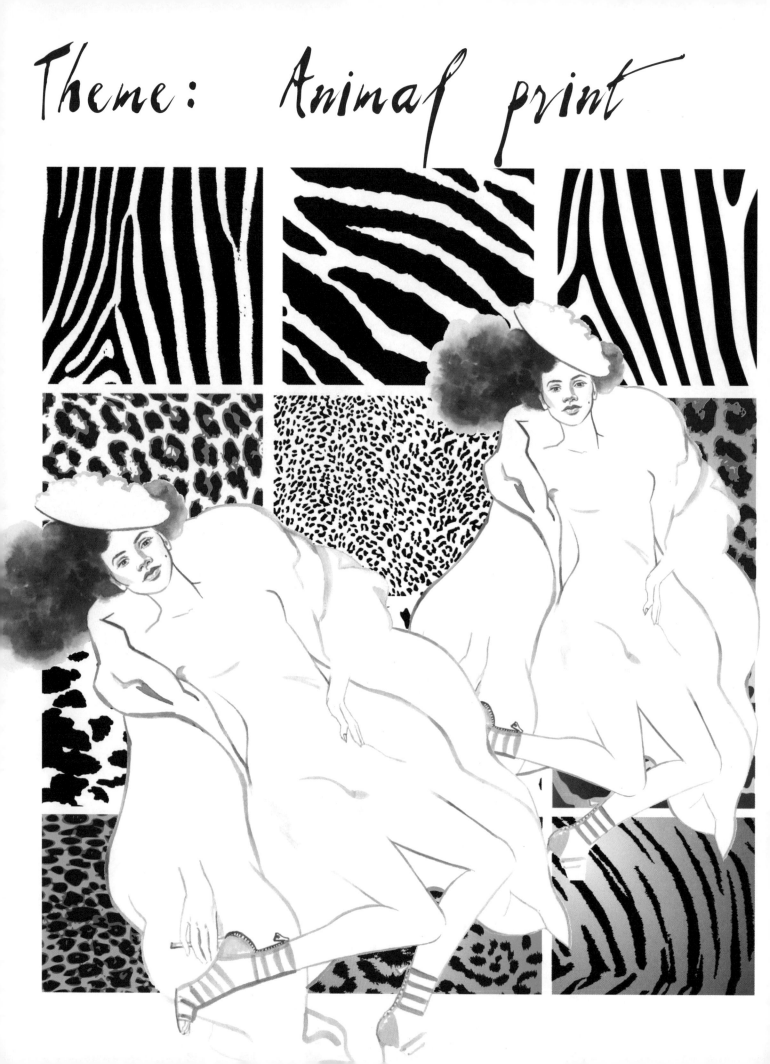

Theme: Animal print

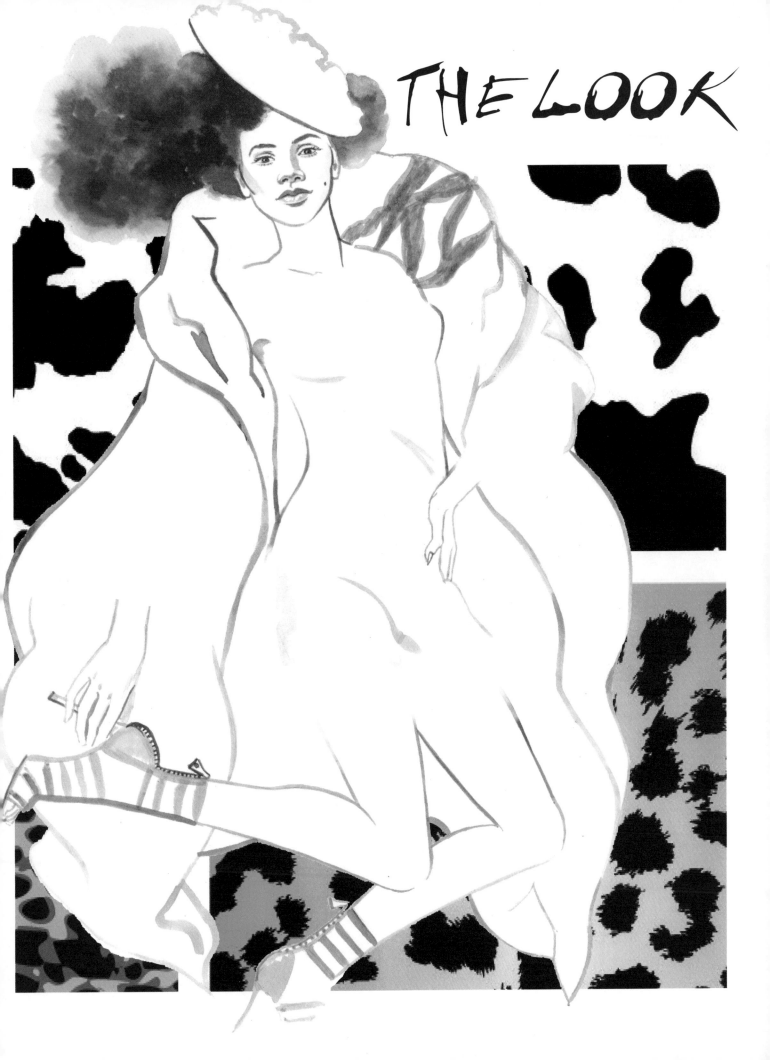

THE LOOK

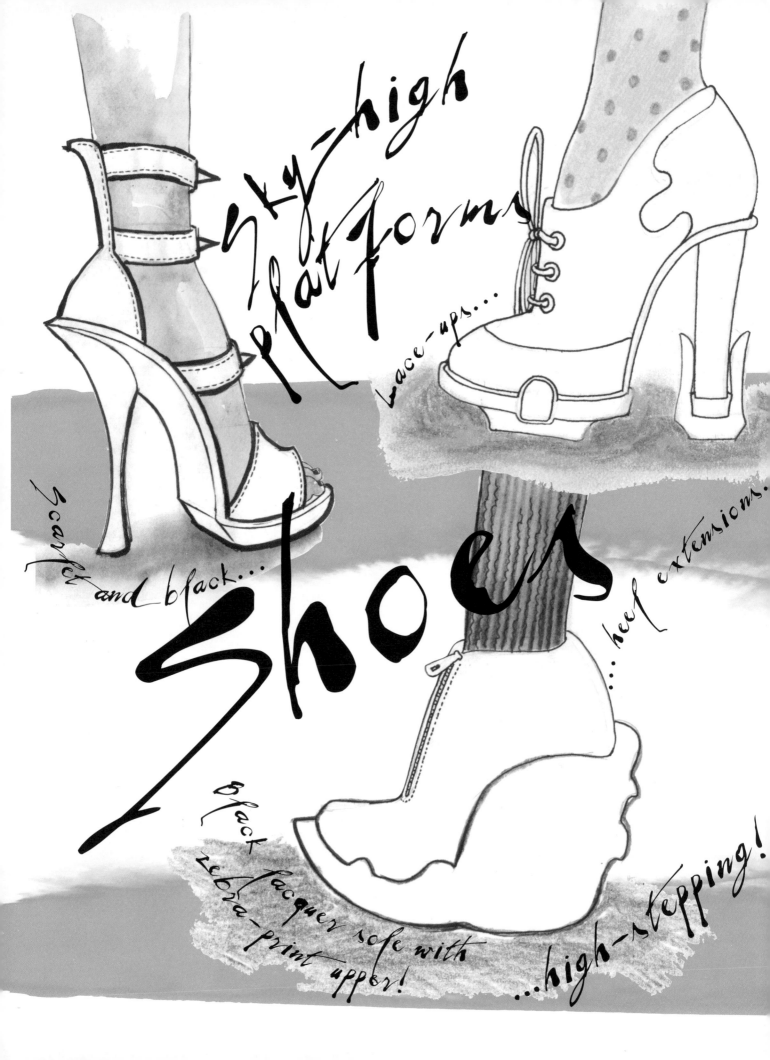

Sky-high
Platforms

Lace-ups...

Scarlet and black...

Shoes

...heel extensions.

black lacquer sole with zebra-print upper!

...high-stepping!

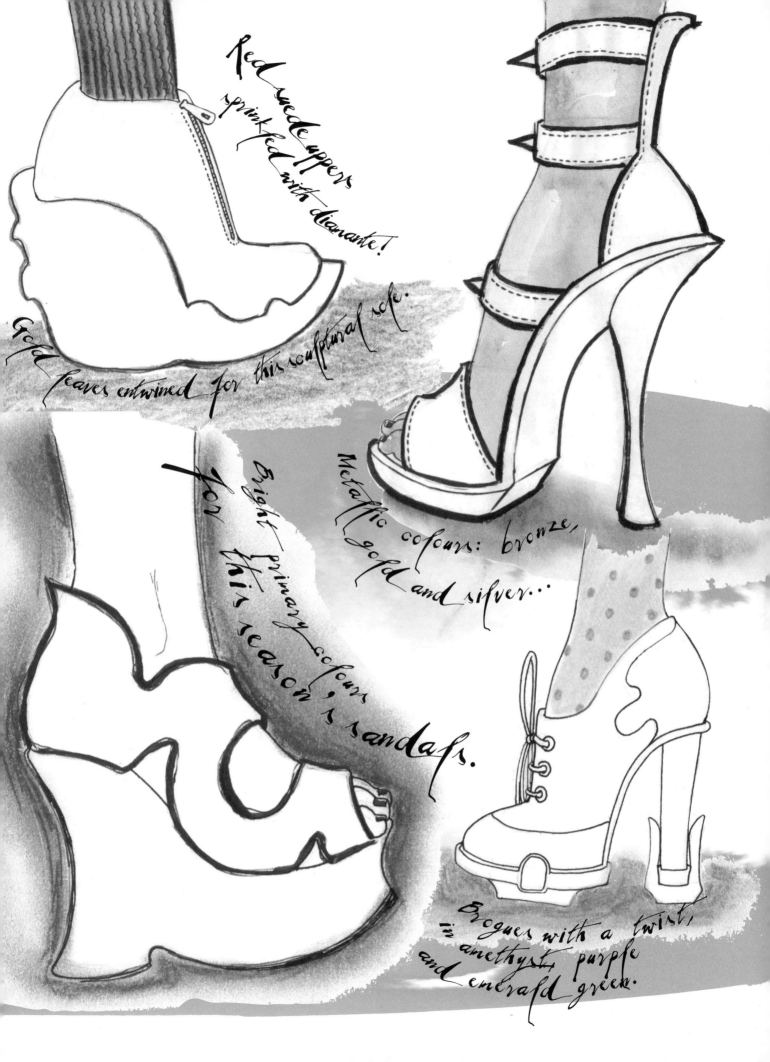

Red suede uppers sprinkled with diamante!

Gold leaves entwined for this sculptural sole.

Bright primary colours for this season's sandals.

Metallic colours: bronze, gold and silver...

Brogues with a twist, in amethyst purple and emerald green.

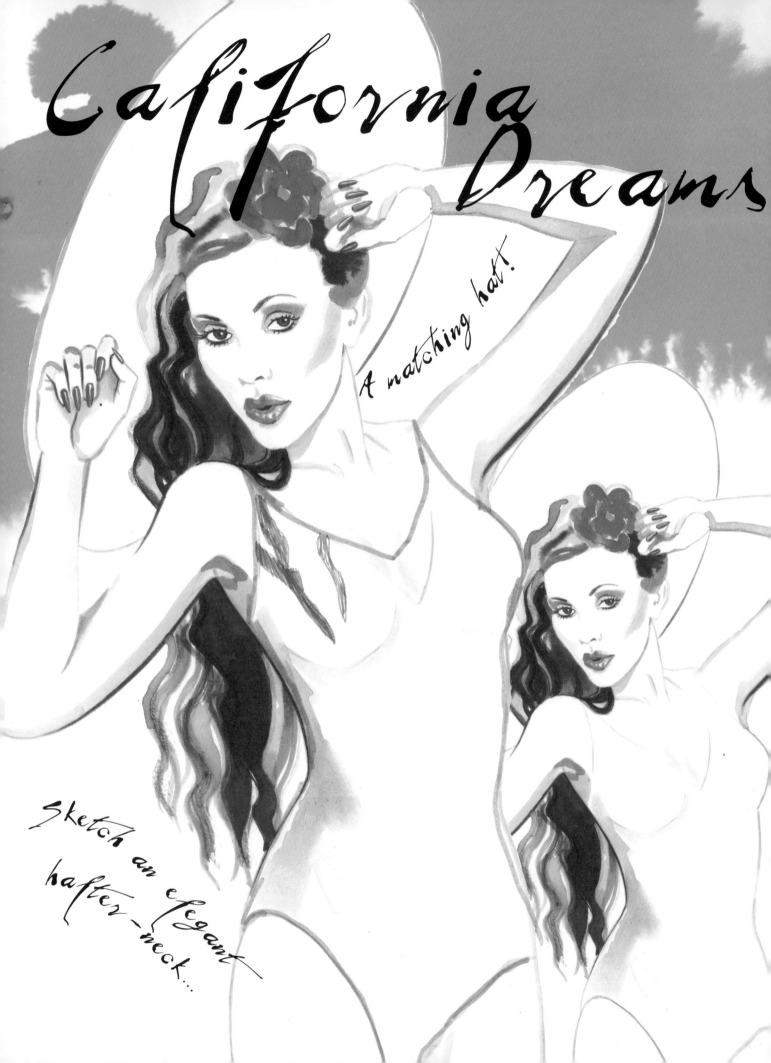

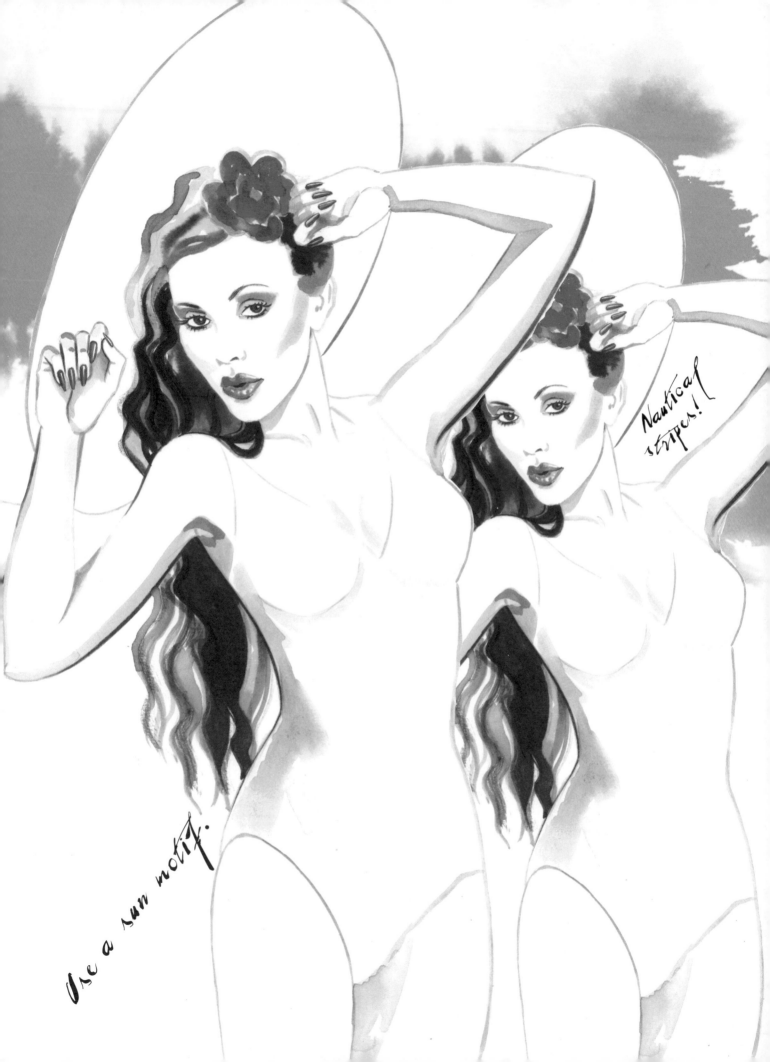

Nautical stripes!

Use a sun motif.

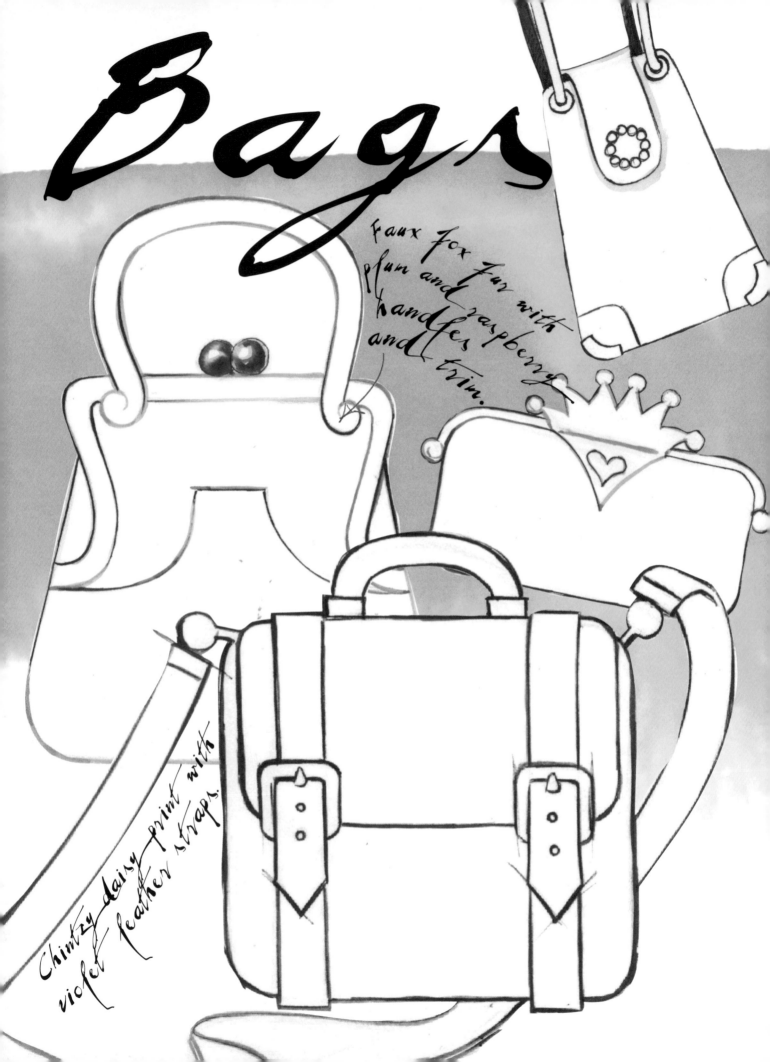

Bags

Faux fox fur with plum and raspberry handles and trim.

Chintzy daisy print with violet feather straps.

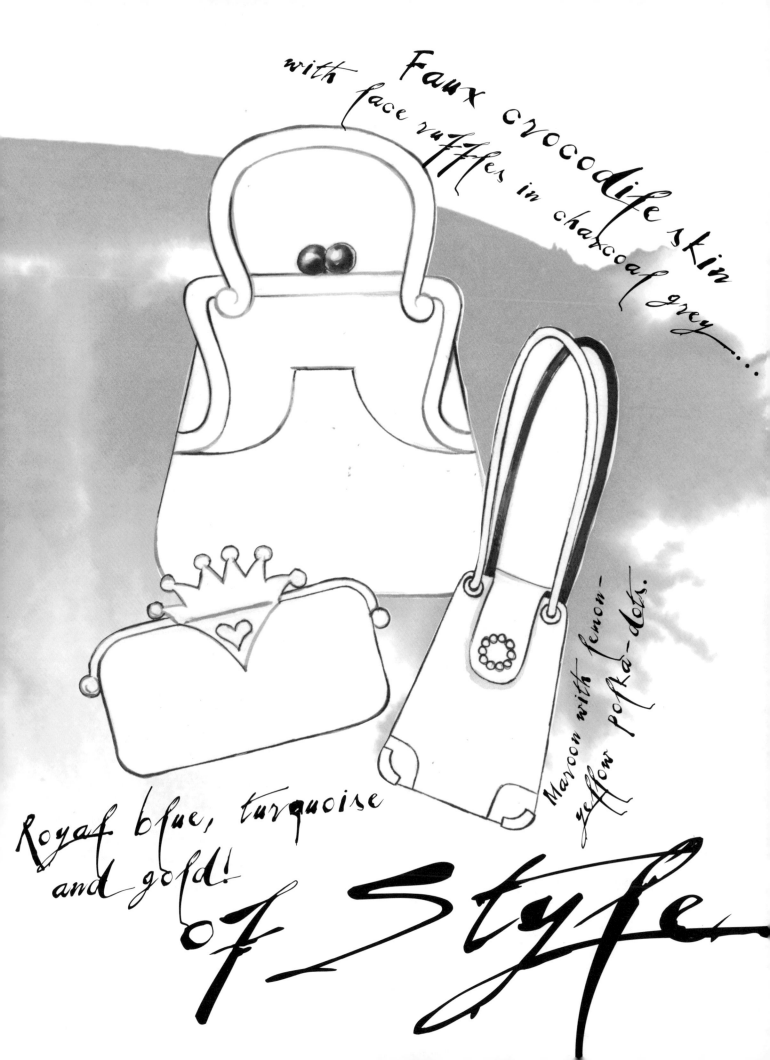

Faux crocodile skin with lace ruffles in charcoal grey...

Maroon with lemon-yellow polka-dots.

Royal blue, turquoise and gold!

of Style

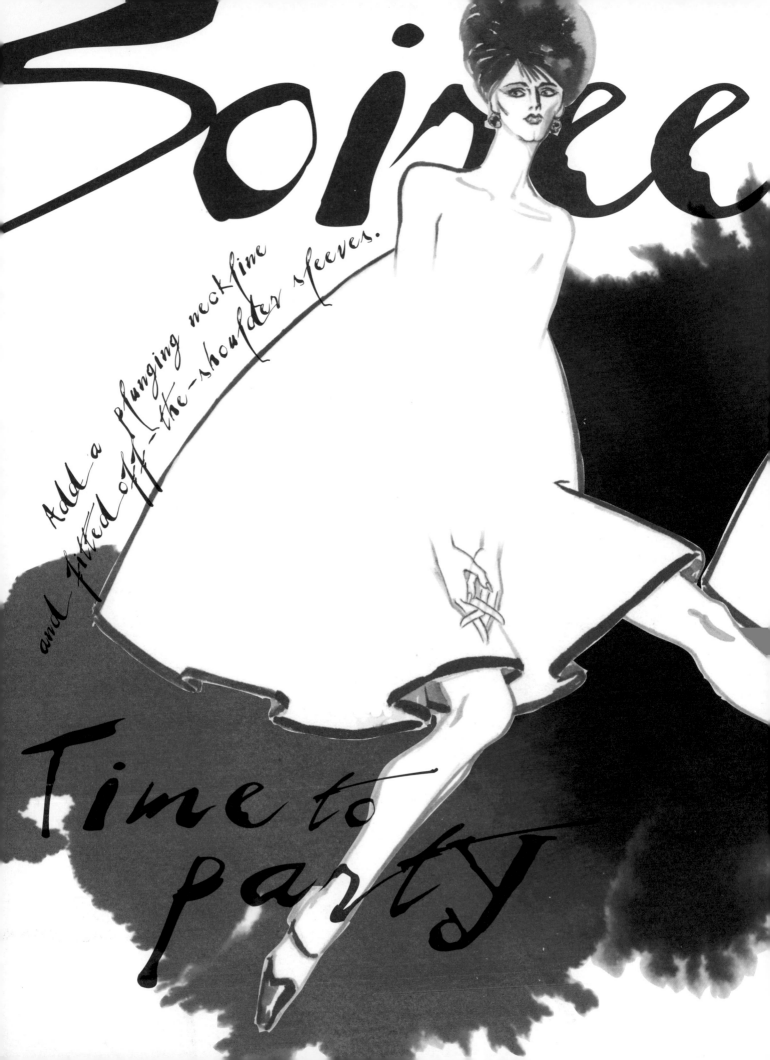

Soirée

Add a plunging neckline and fitted off-the-shoulder sleeves.

Time to party

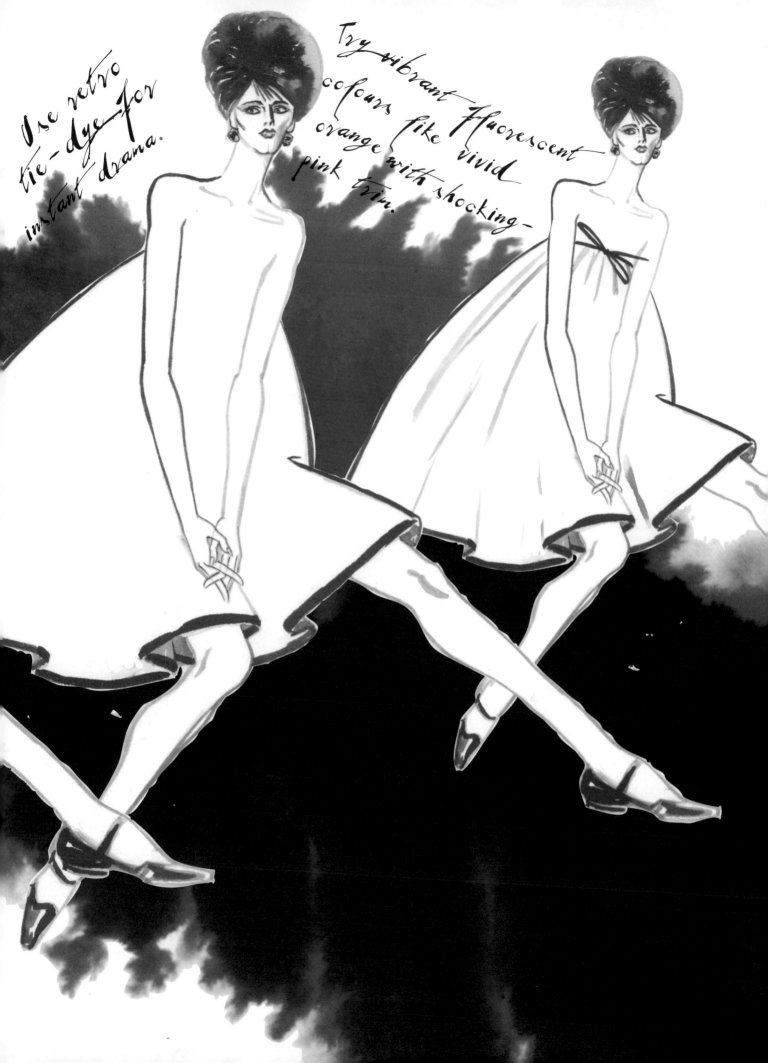

Use retro tie-dye for instant drama.

Try vibrant fluorescent colours like vivid orange with shocking pink trim.

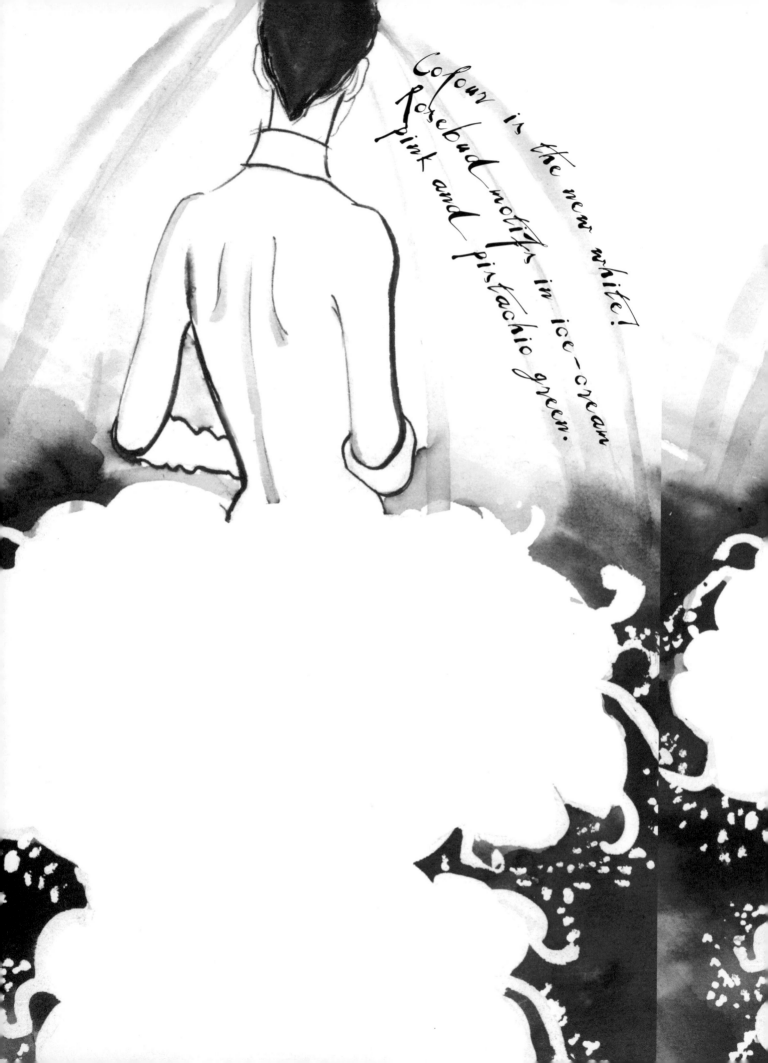

Colour is the new white!
Rosebud motifs in ice-cream
pink and pistachio green.

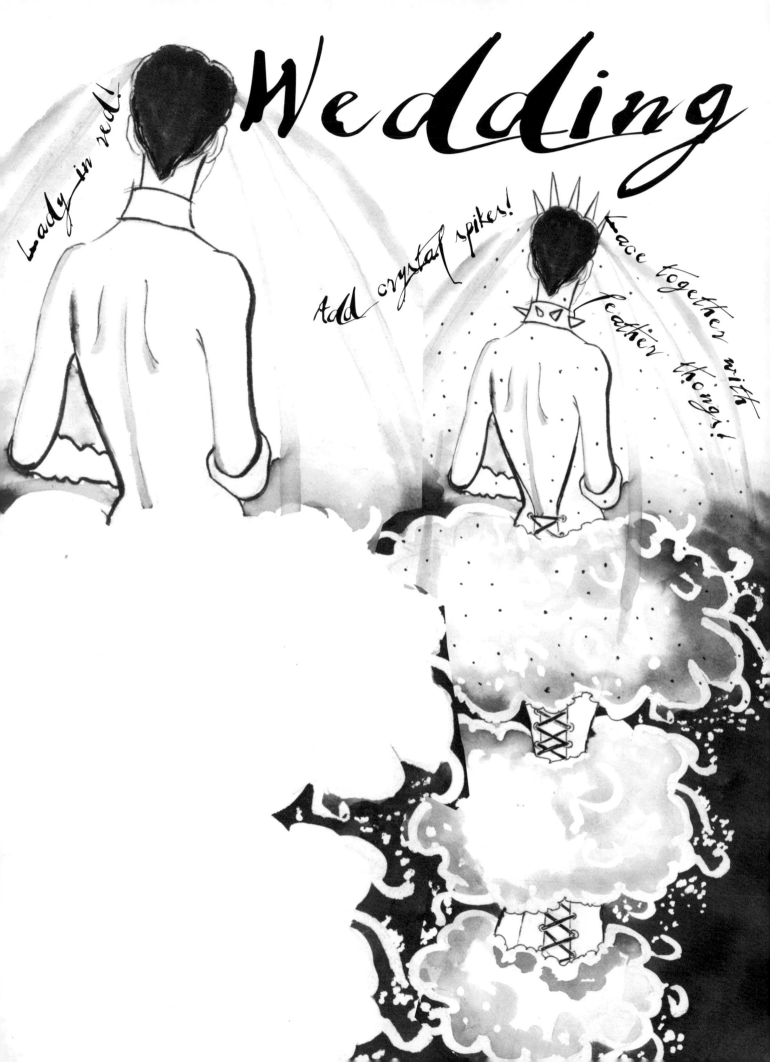

Theme:
The Notebook
Collection

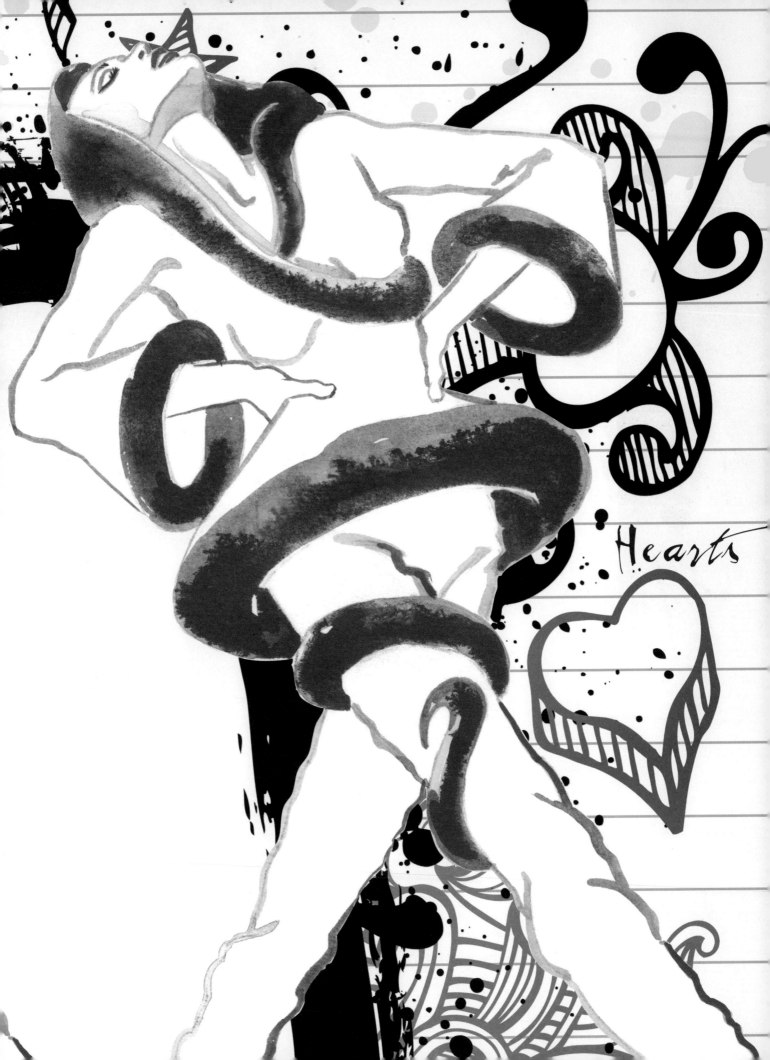

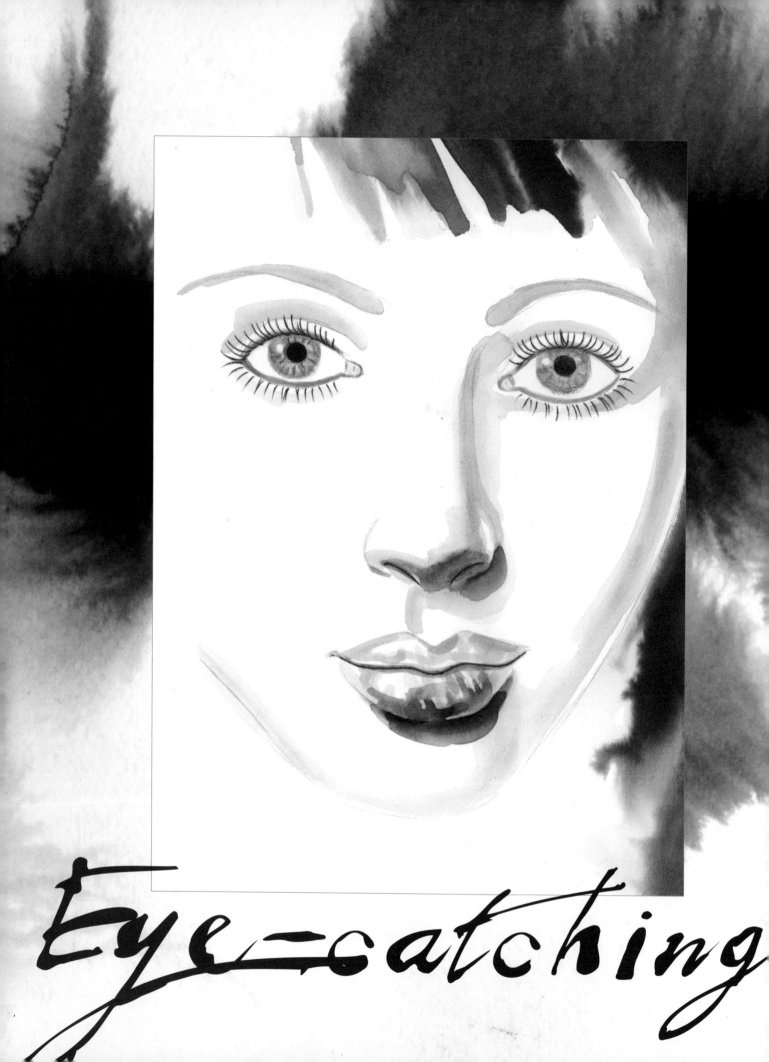

Eye-catching

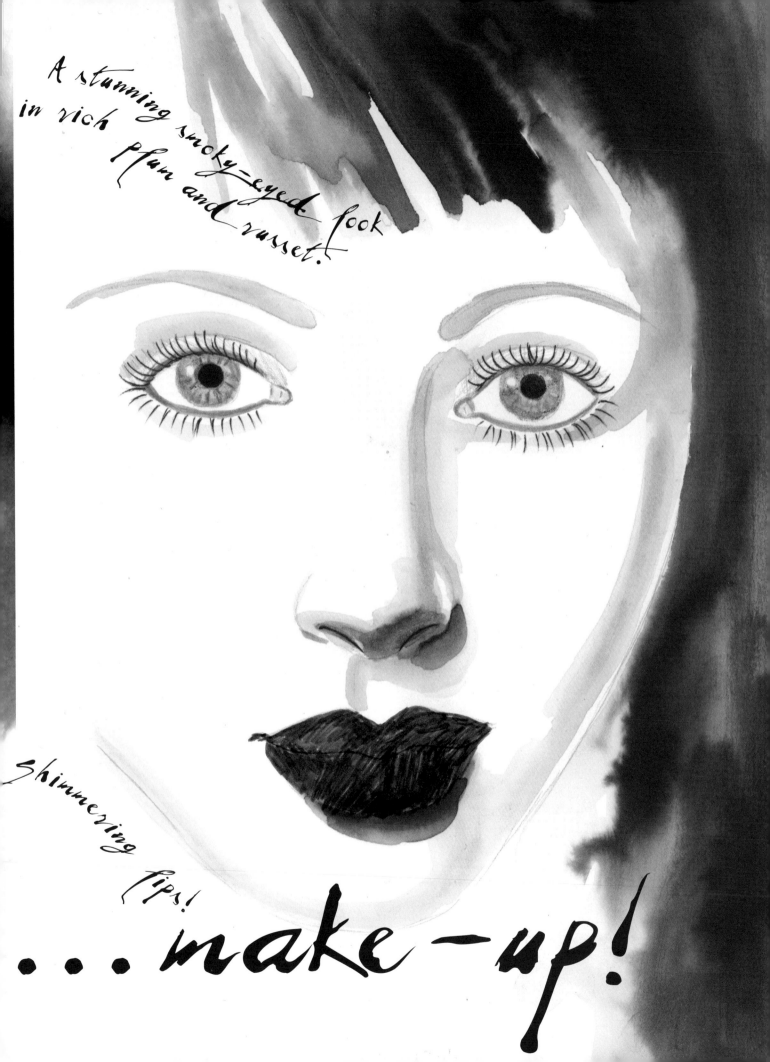

A stunning smoky-eyed look in rich plum and russet.

Shimmering lips!

....make-up!

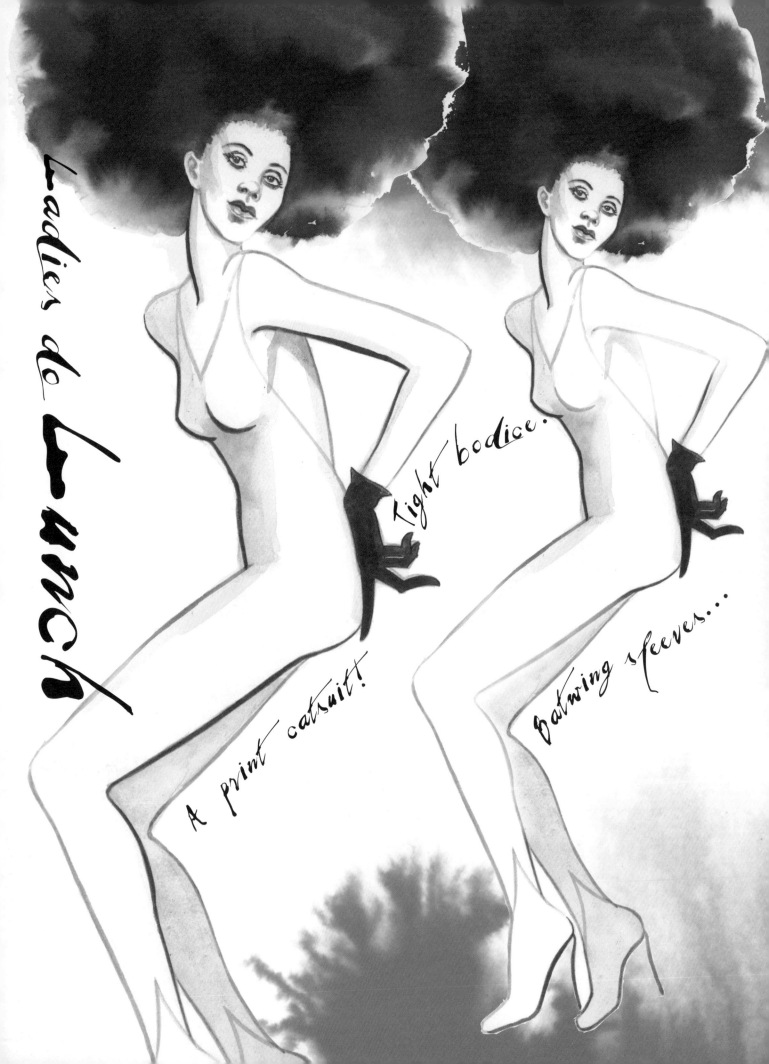

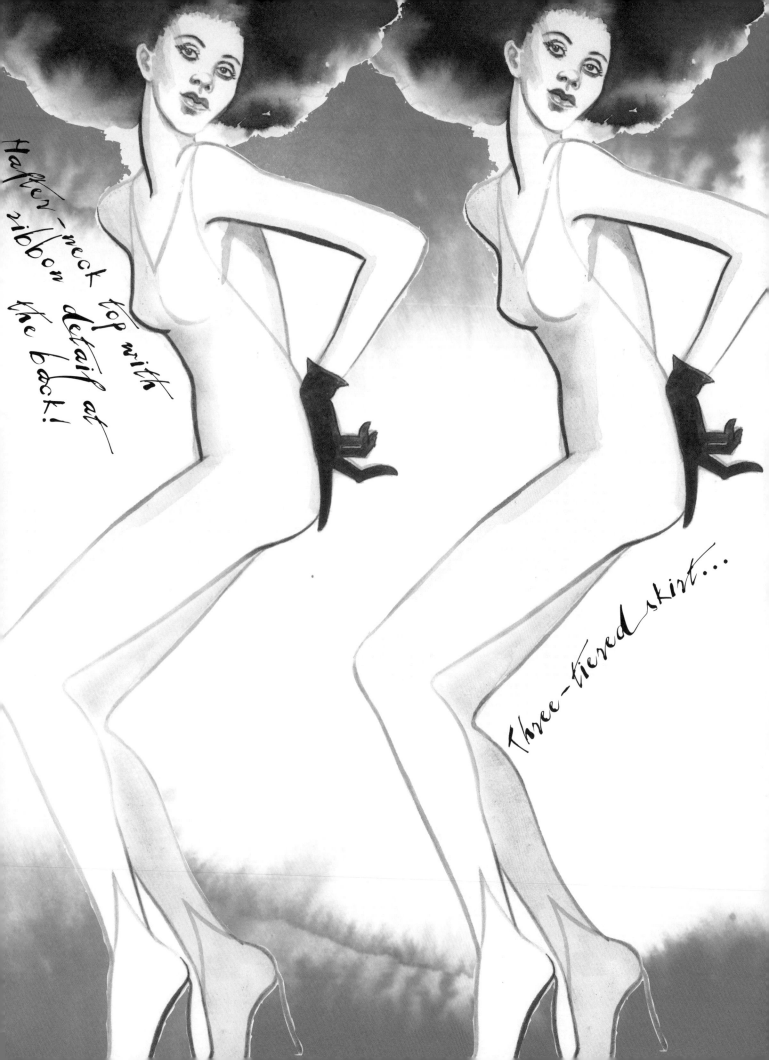

Halter-neck top with ribbon detail at the back!

Three-tiered skirt...

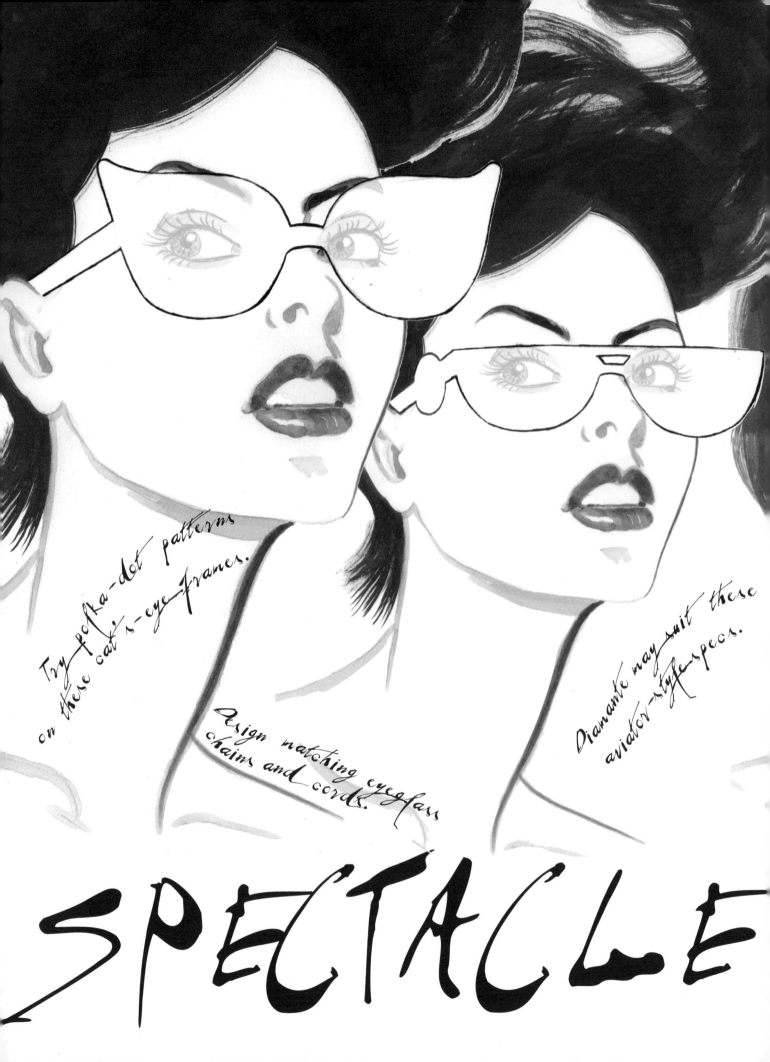

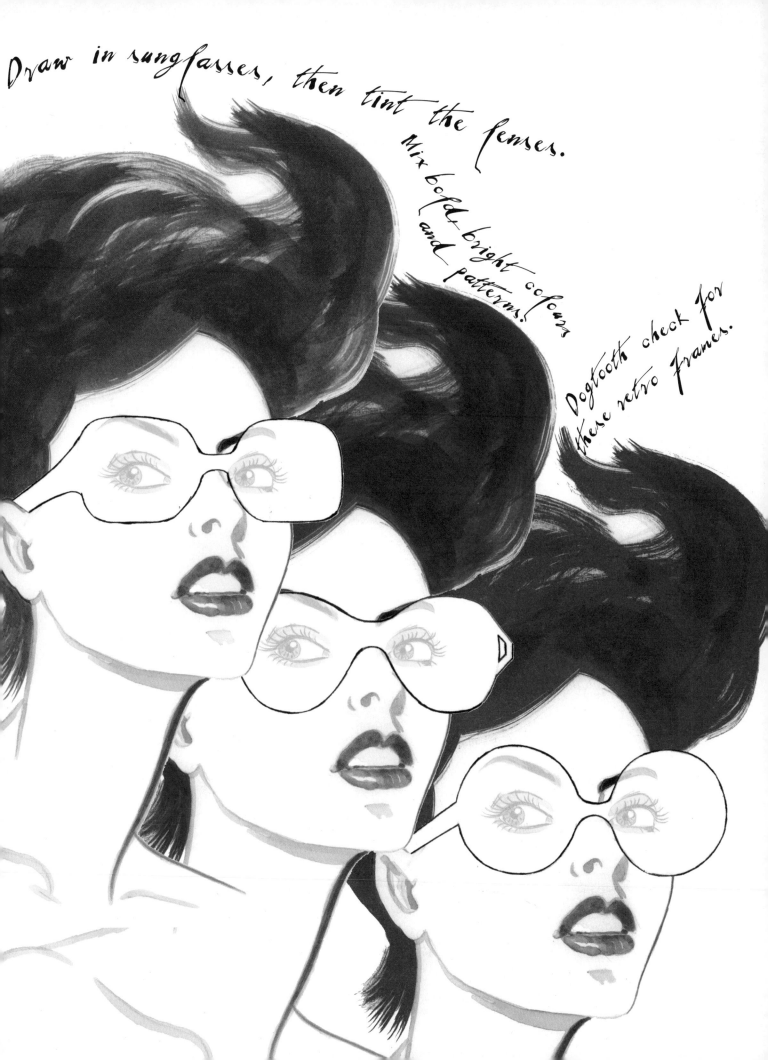

Draw in sunglasses, then tint the lenses.

Mix bold bright colours and patterns!

Dogtooth check for these retro frames.

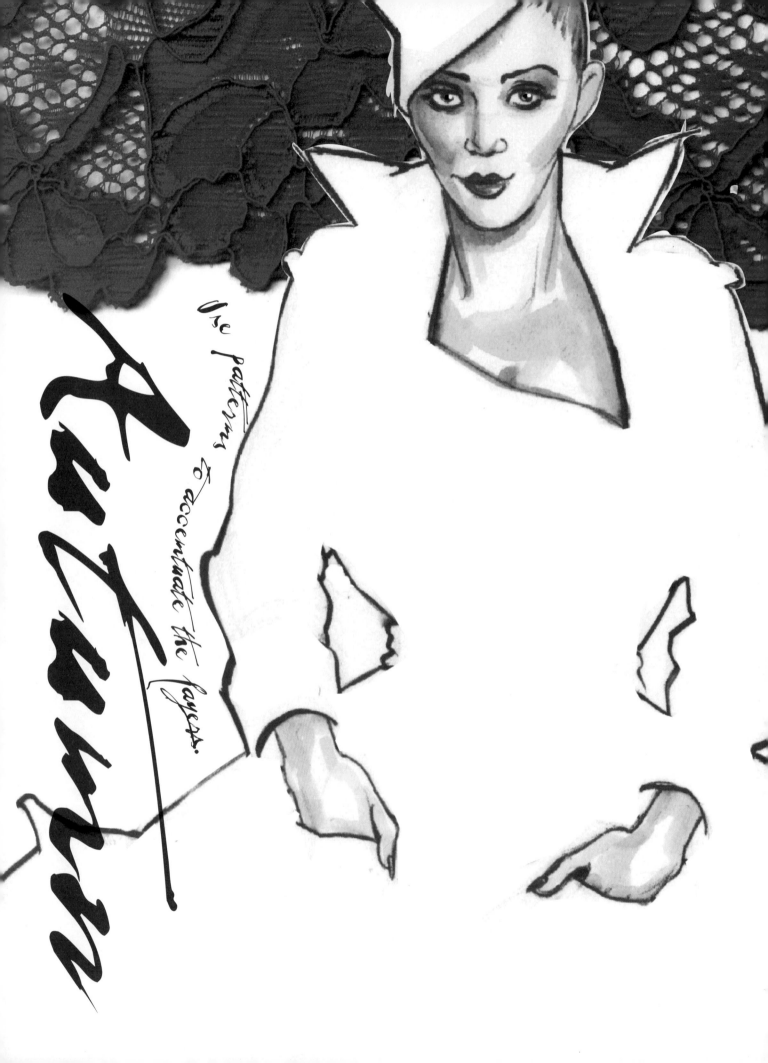

Use patterns to accentuate the layers.

Autumn

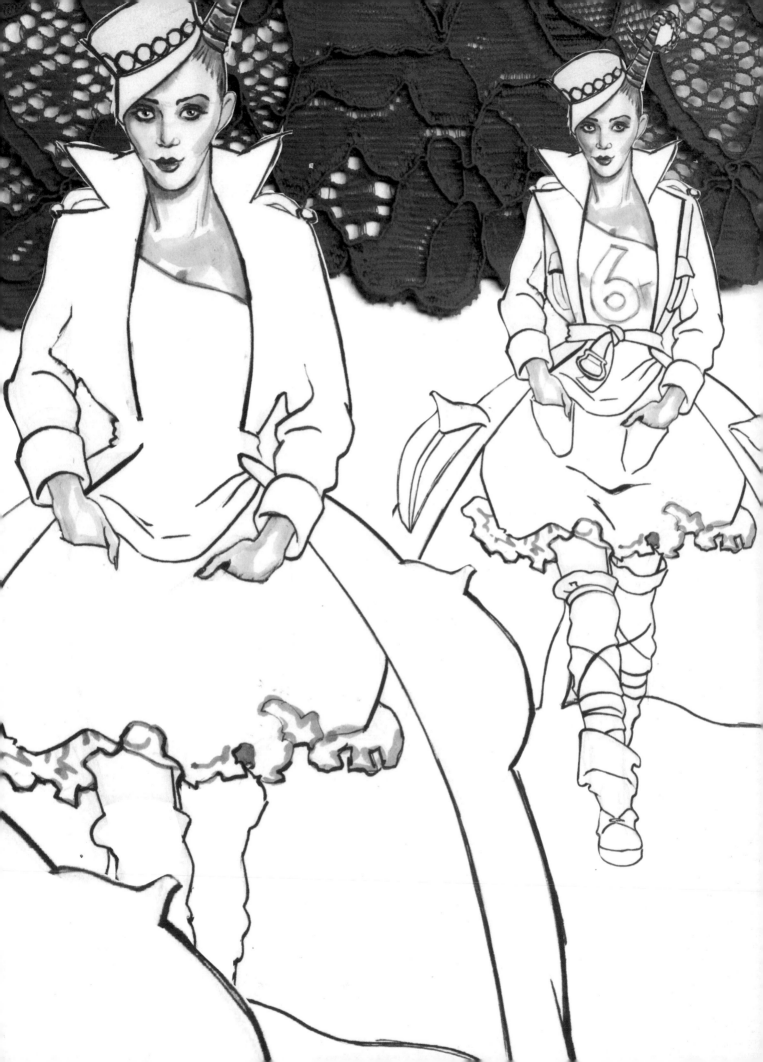

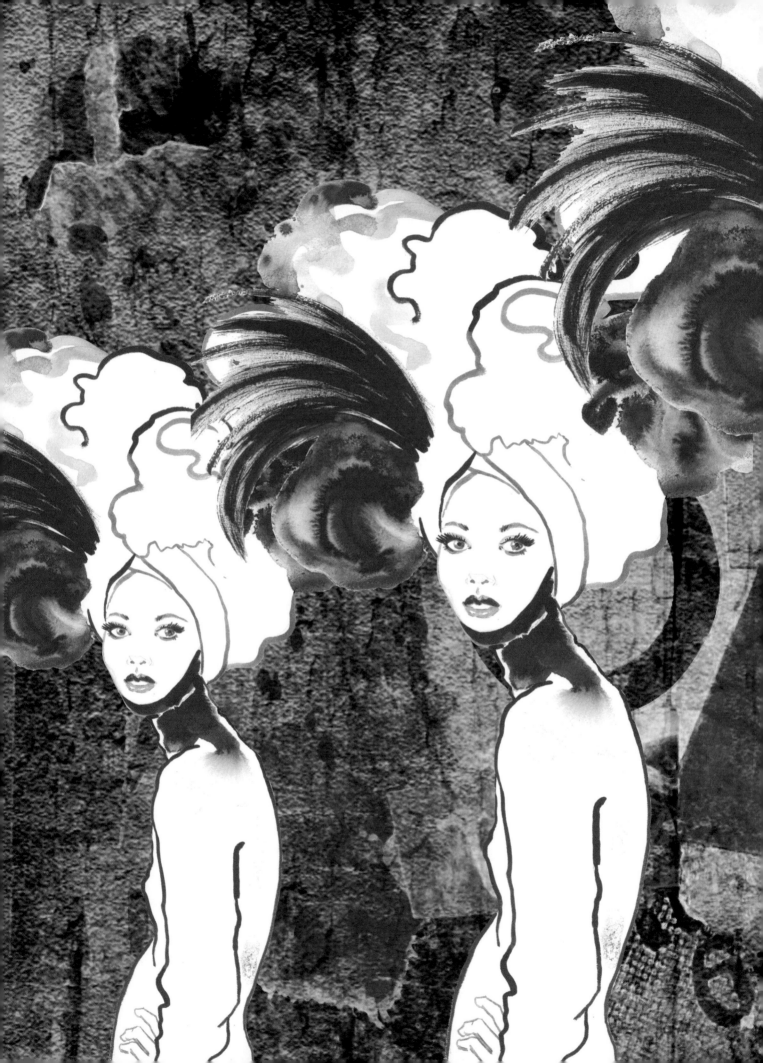

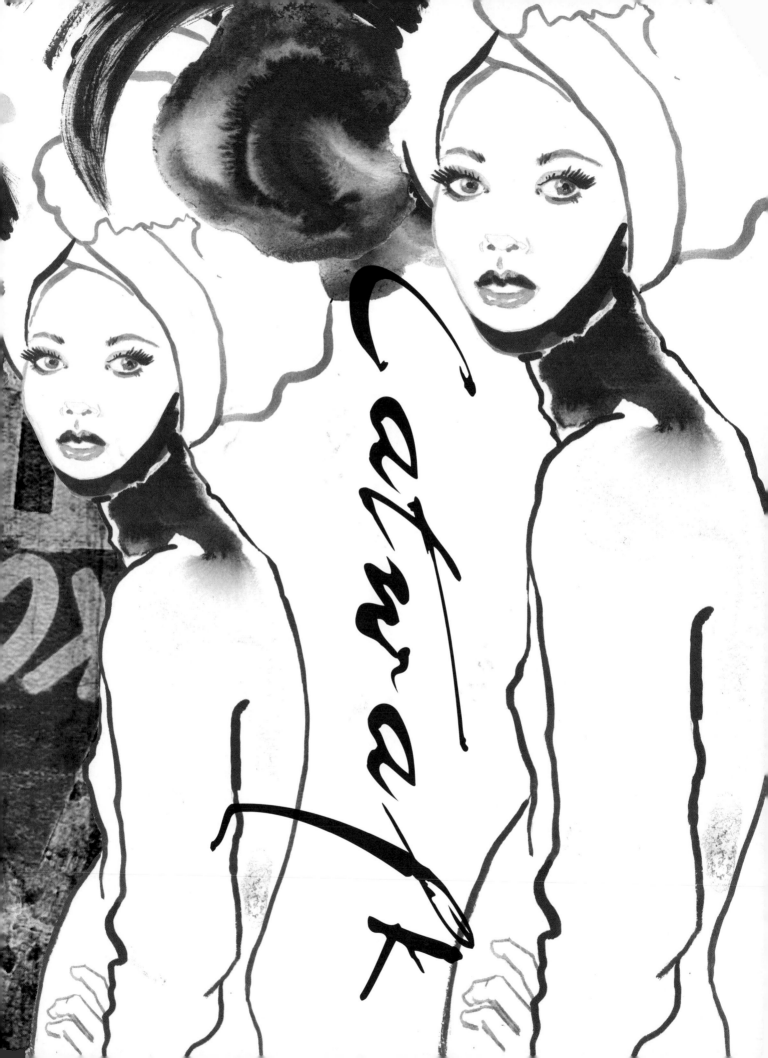

Design your own nail art!

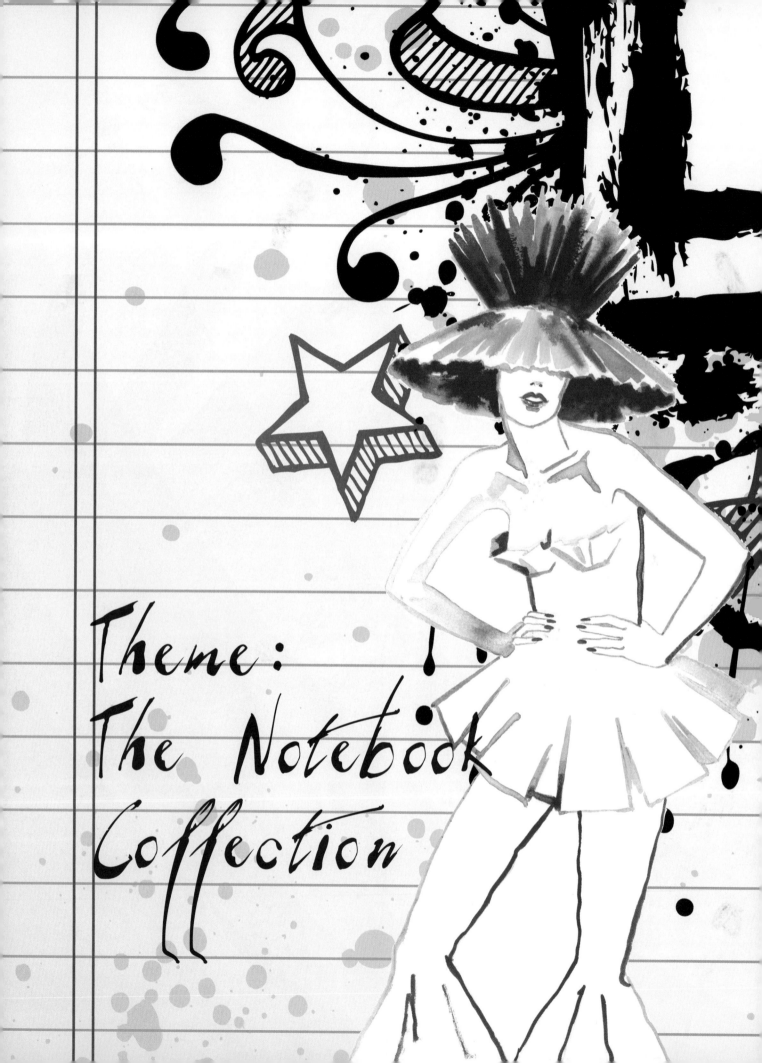

Theme:
The Notebook
Collection

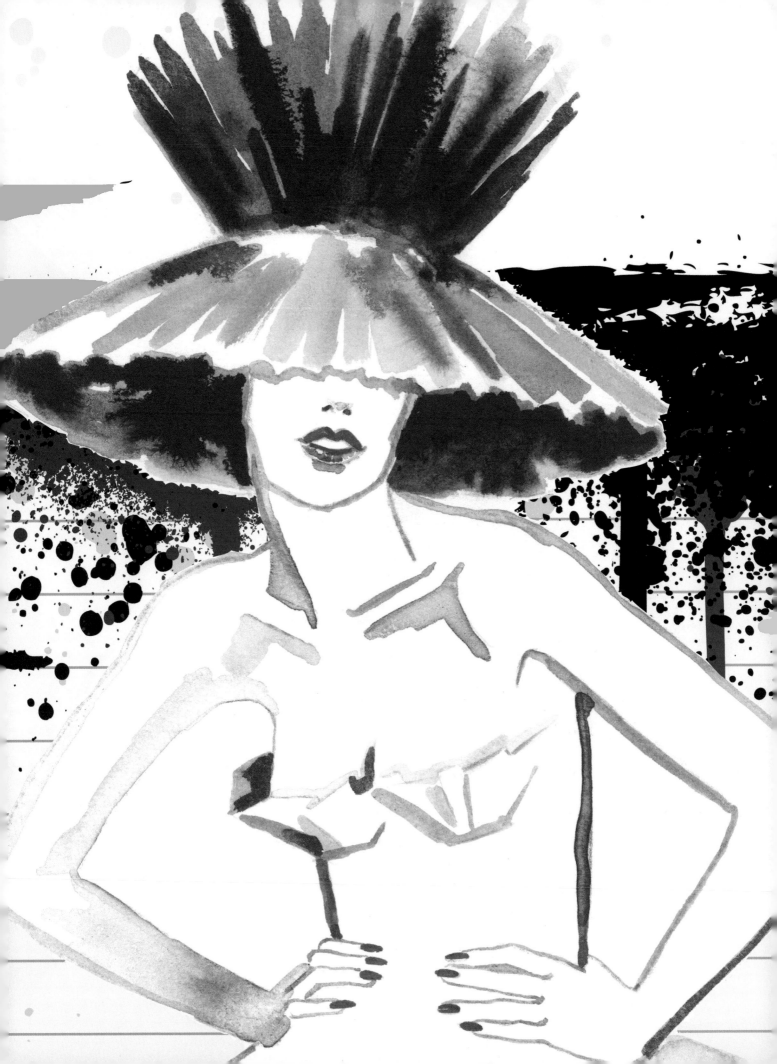

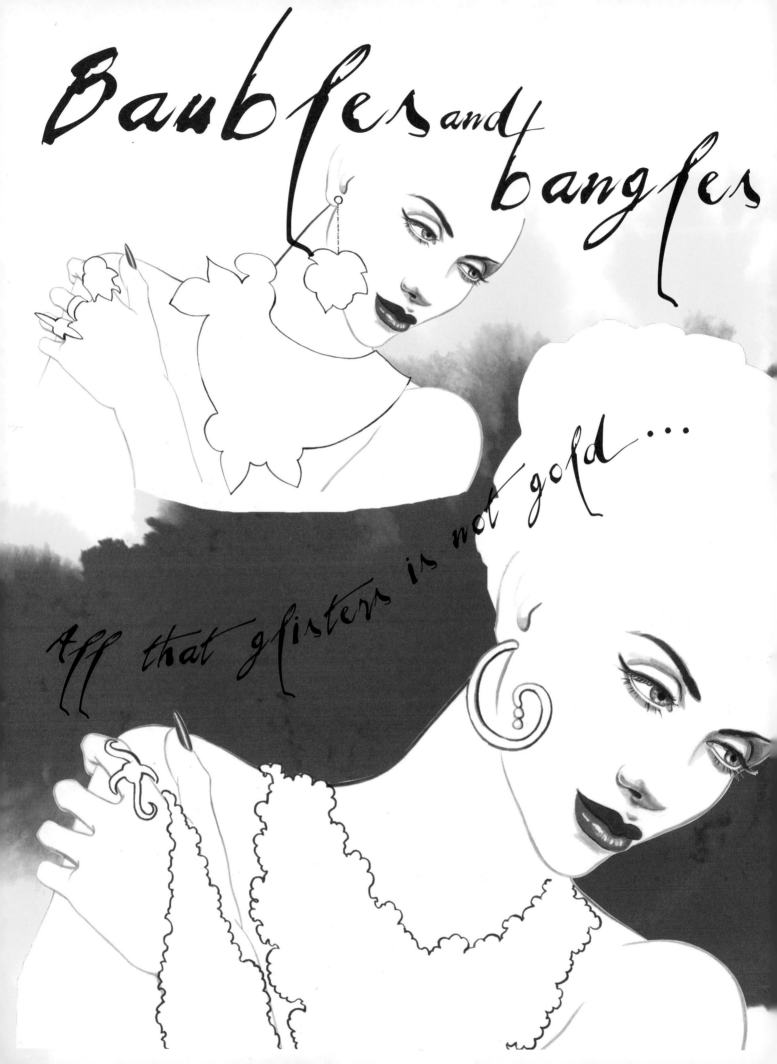

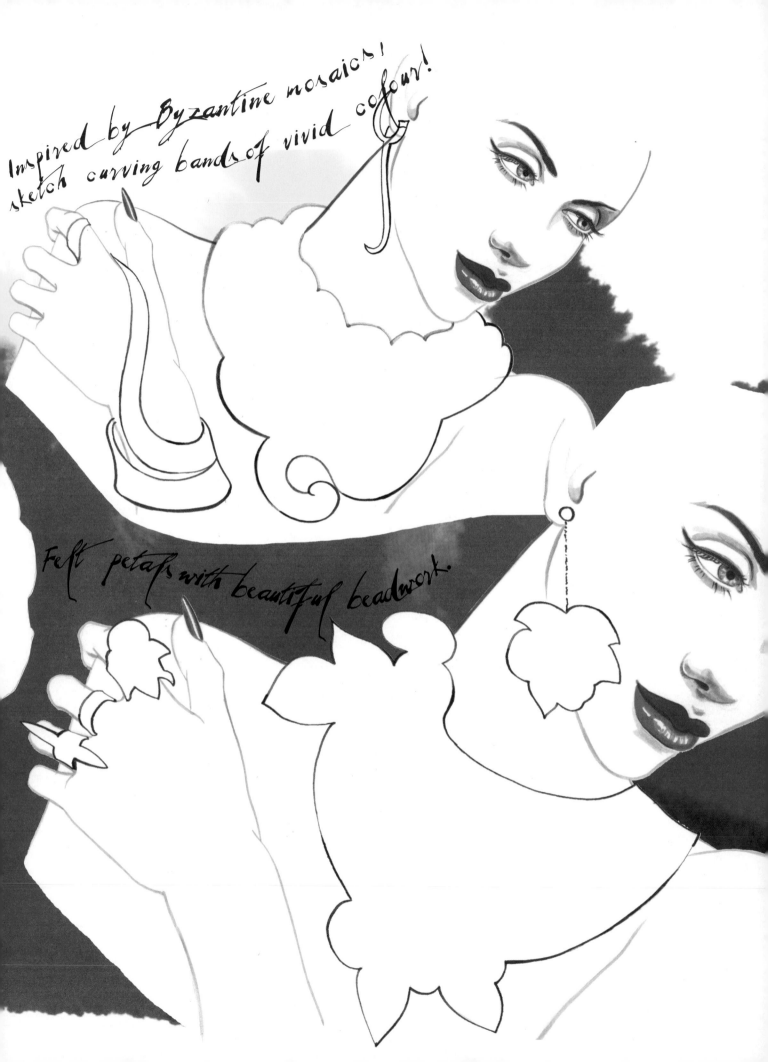

Inspired by Byzantine mosaics! sketch curving bands of vivid colour!

Felt petals with beautiful beadwork.

DOODLE

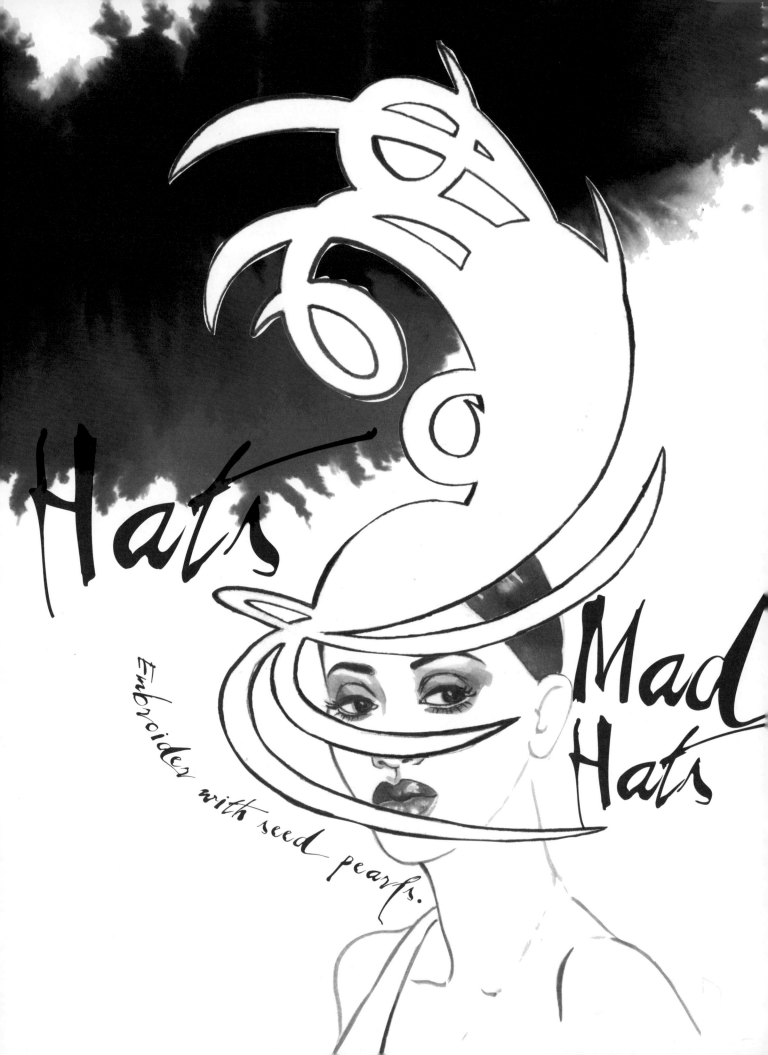

Hats

Mad
Hats

Embroider with seed pearls.

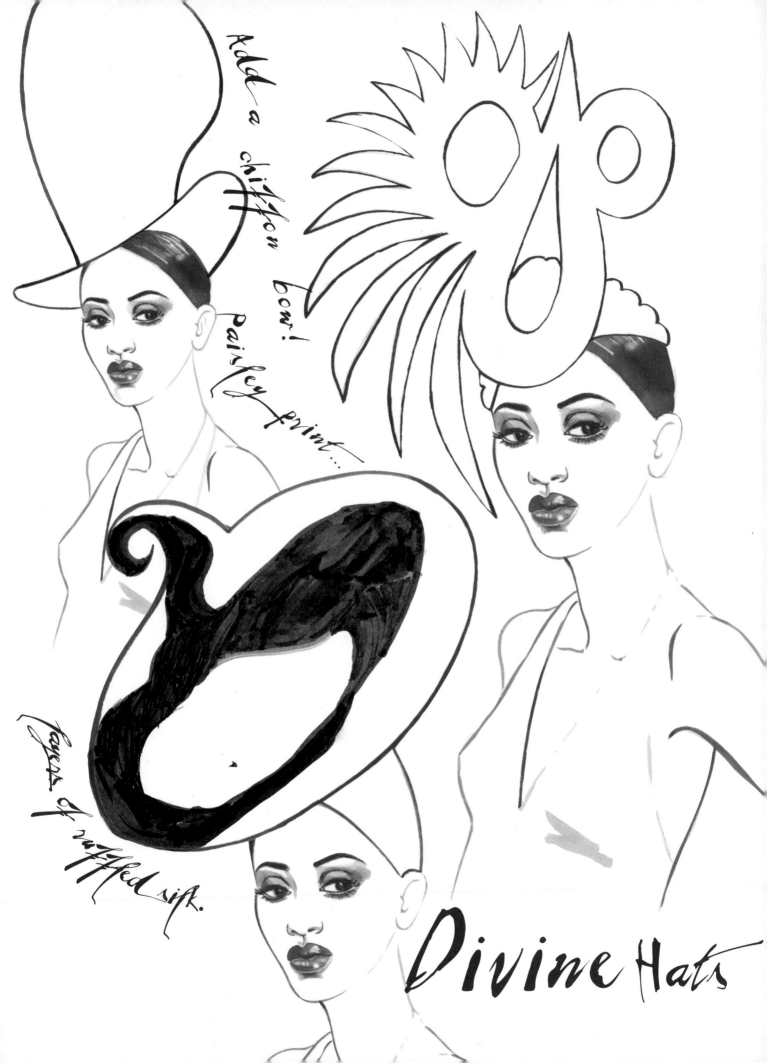

Add a chiffon bow!

Paisley print...

Layers of ruffled silk.

Divine Hats

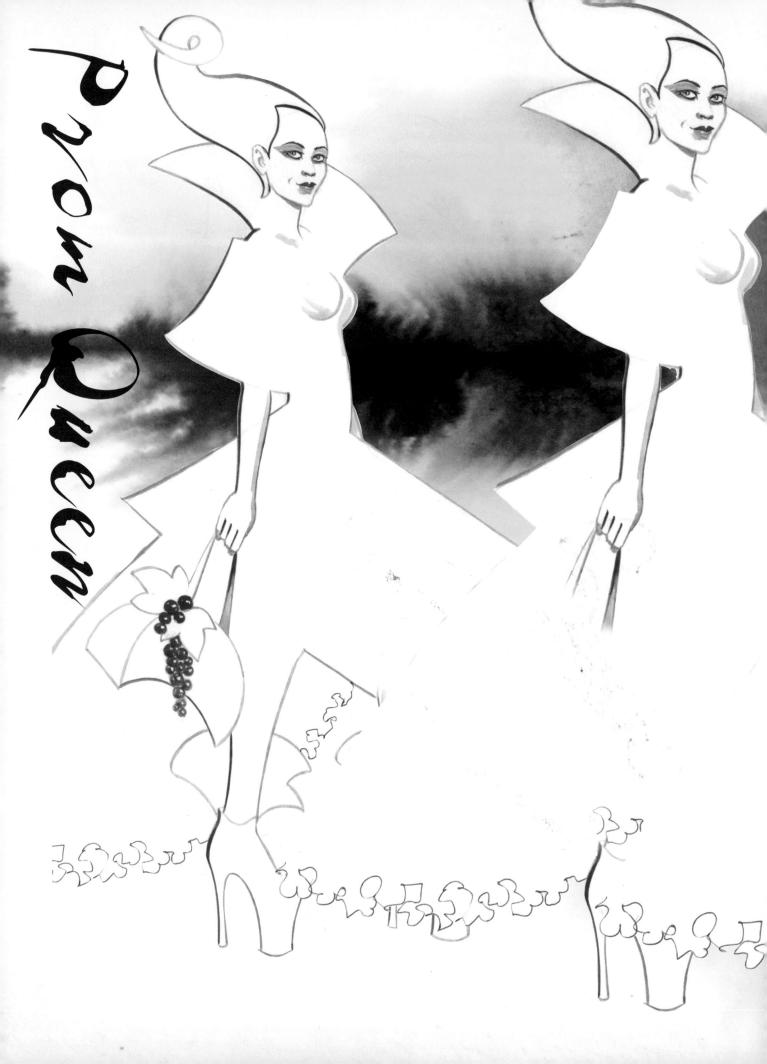

Prom Queen

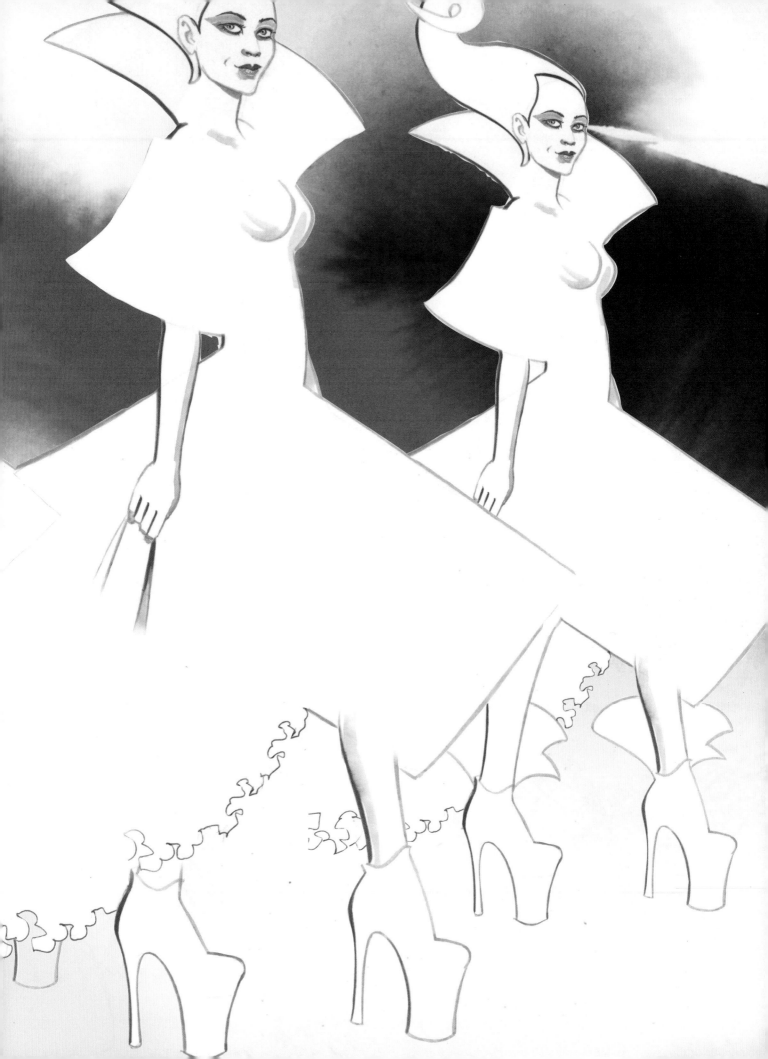

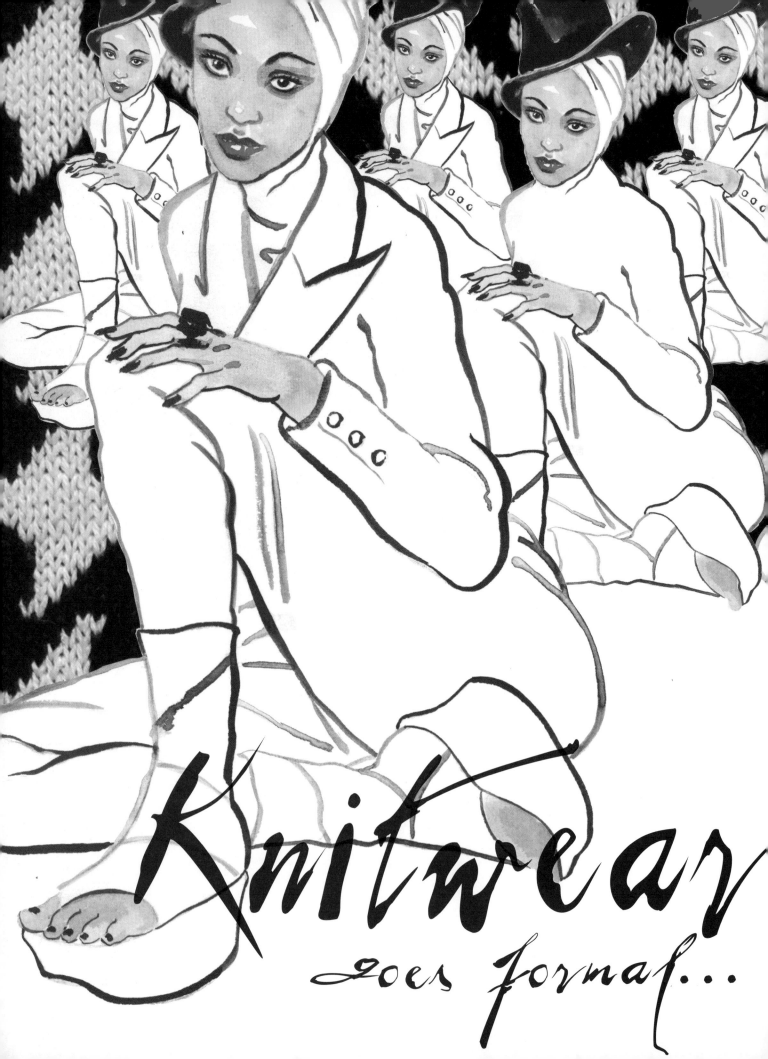

Knitwear

goes formal....

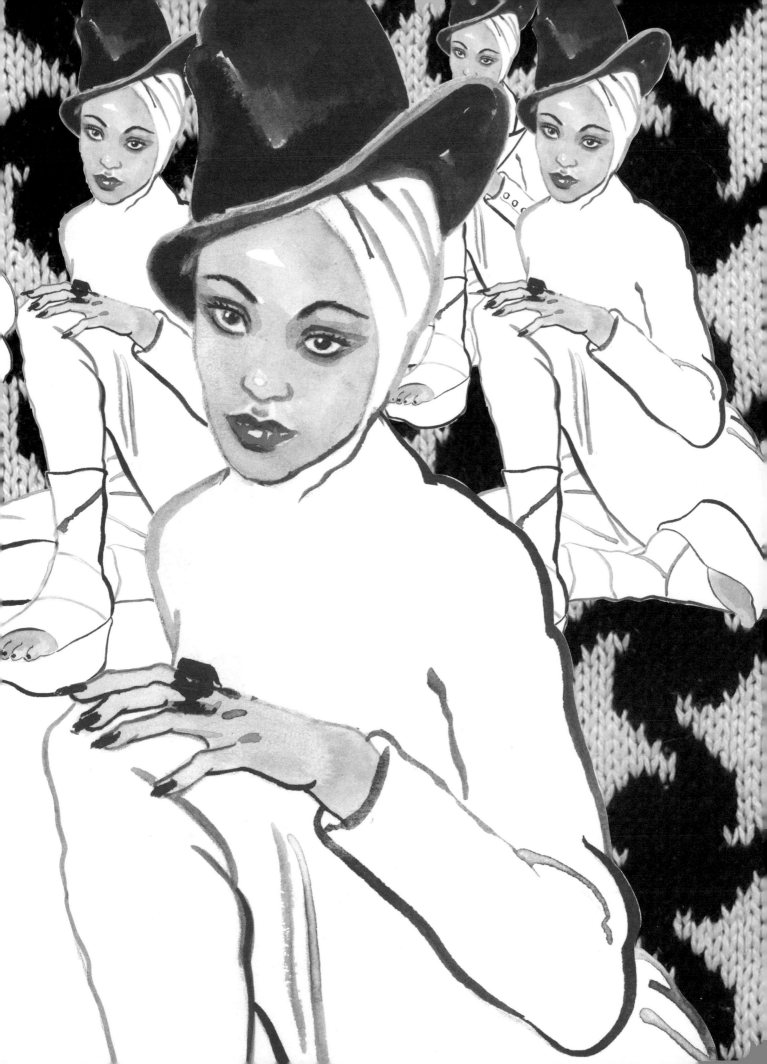

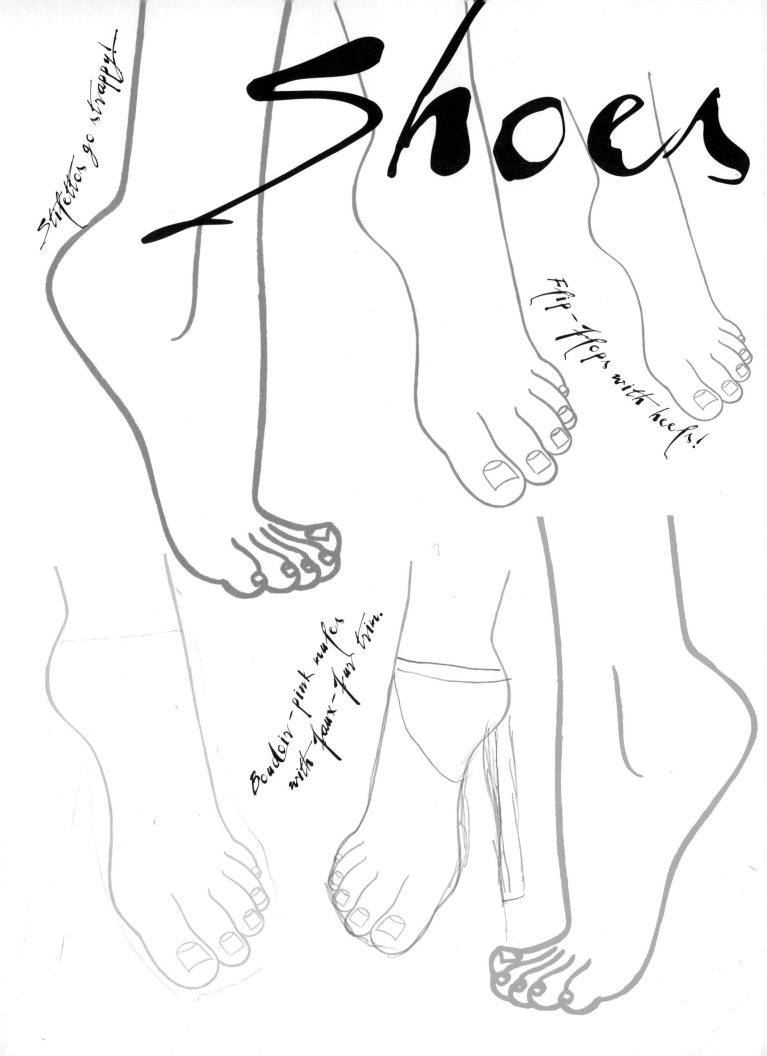

Shoes

Stilettos go strappy.

Flip-Flops with heels!

Boudoir-pink mules with faux-fur trim.

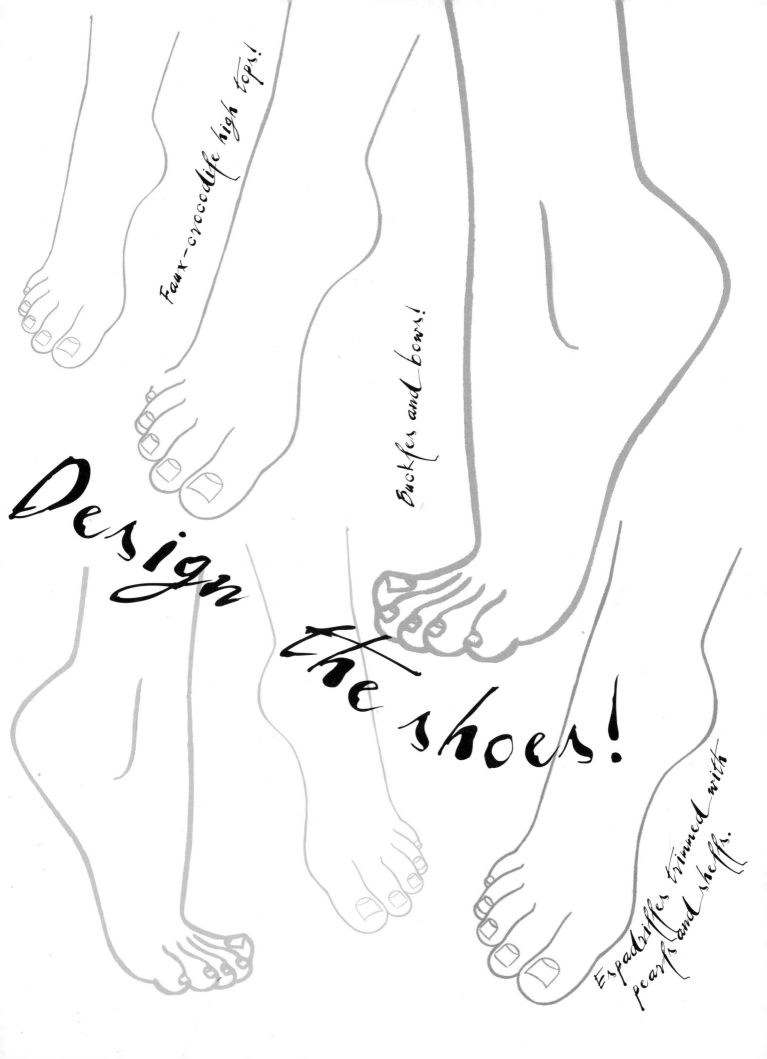

Faux-crocodile high tops!

Buckles and bows!

Design the shoes!

Espadrilles trimmed with pearls and shells.

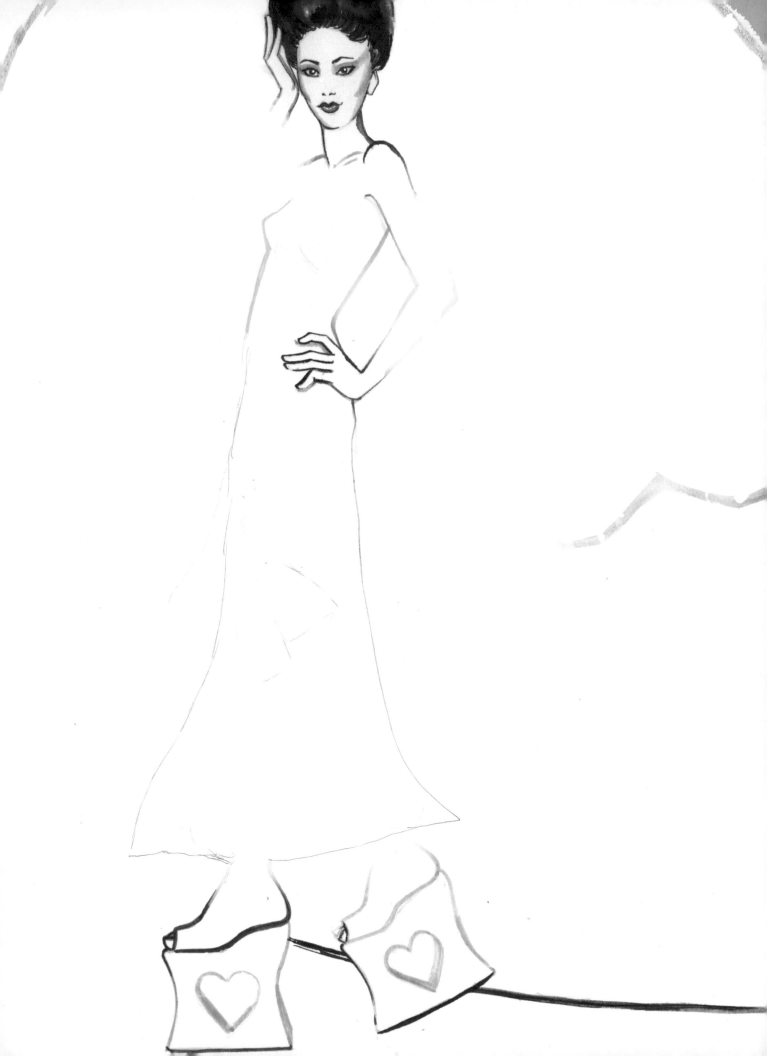

Wedded bliss

East meets West; take inspiration from opulent Oriental designs. Use sweeping lines to create dramatic, sculptural shapes.

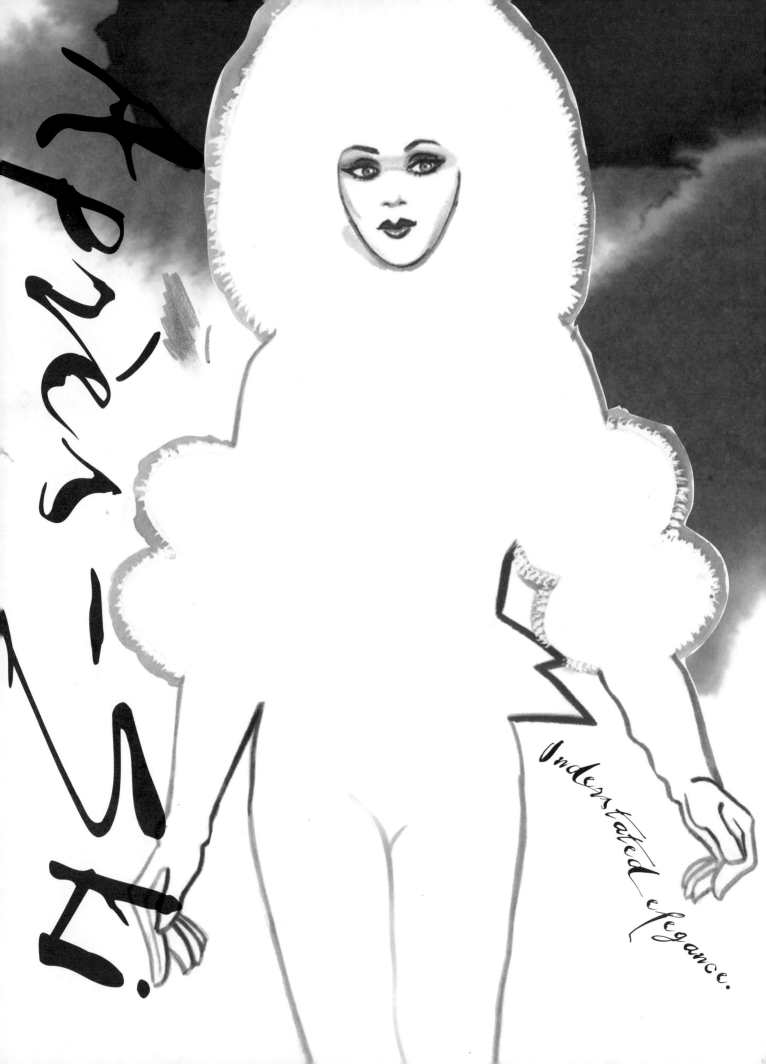

APRES-SKI.

Understated elegance.

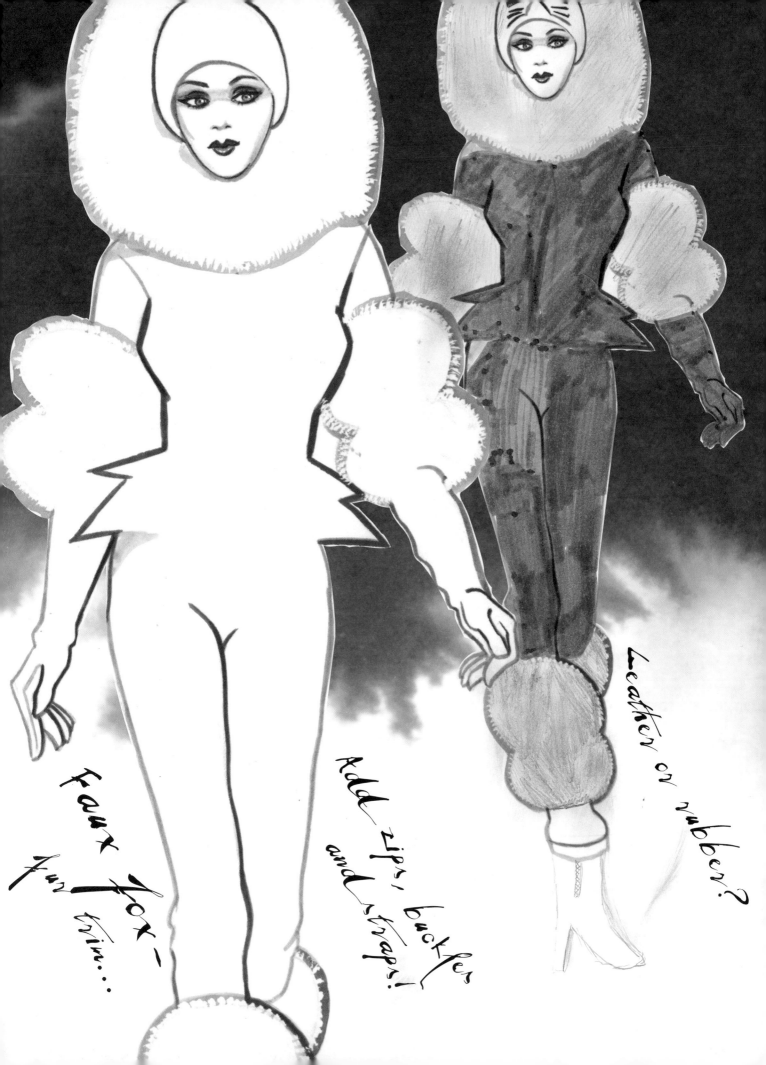

Faux fox -
fur trim...

Add zips, buckles
and straps!

Leather or rubber?

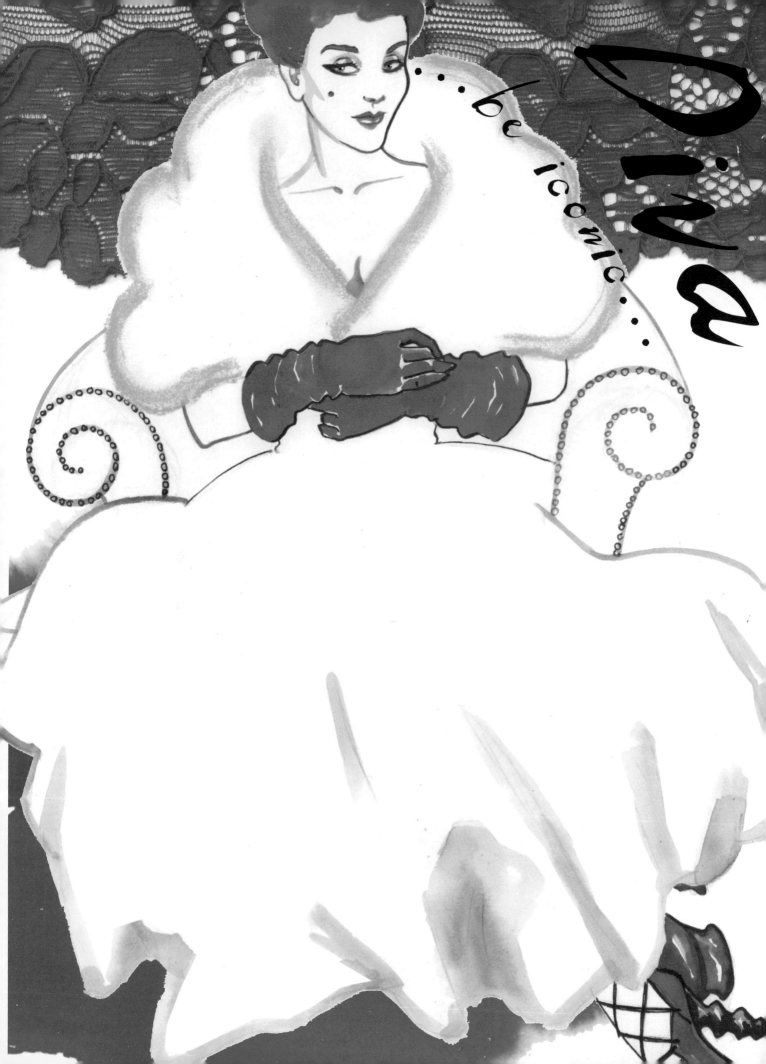

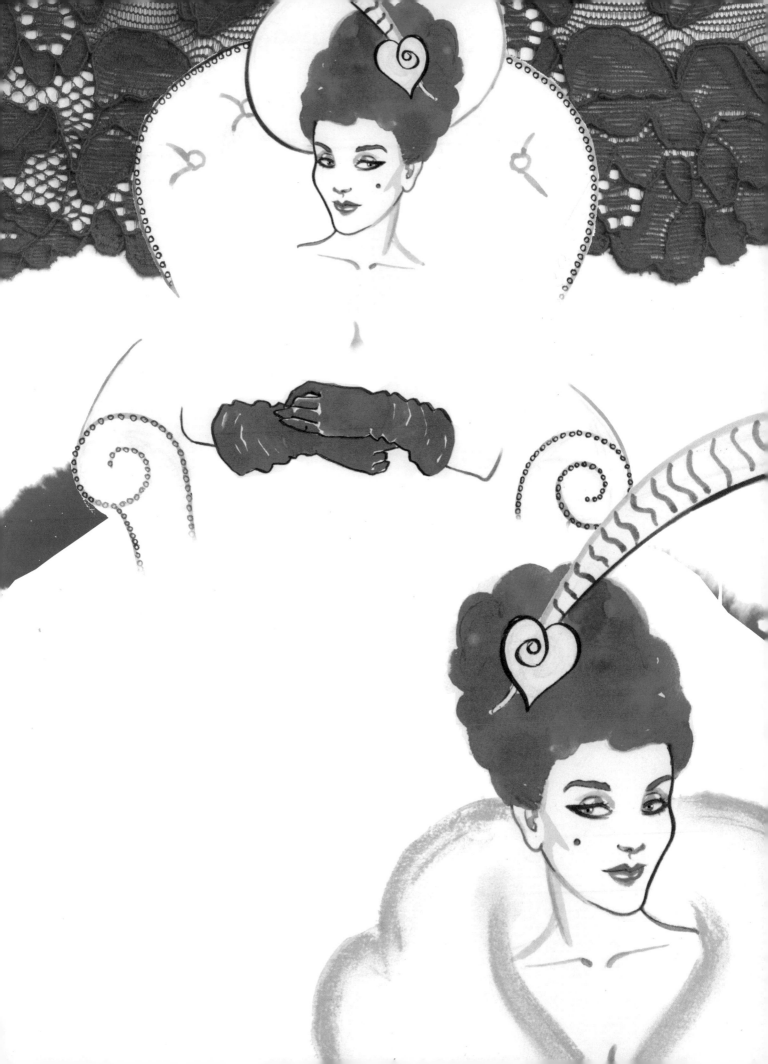

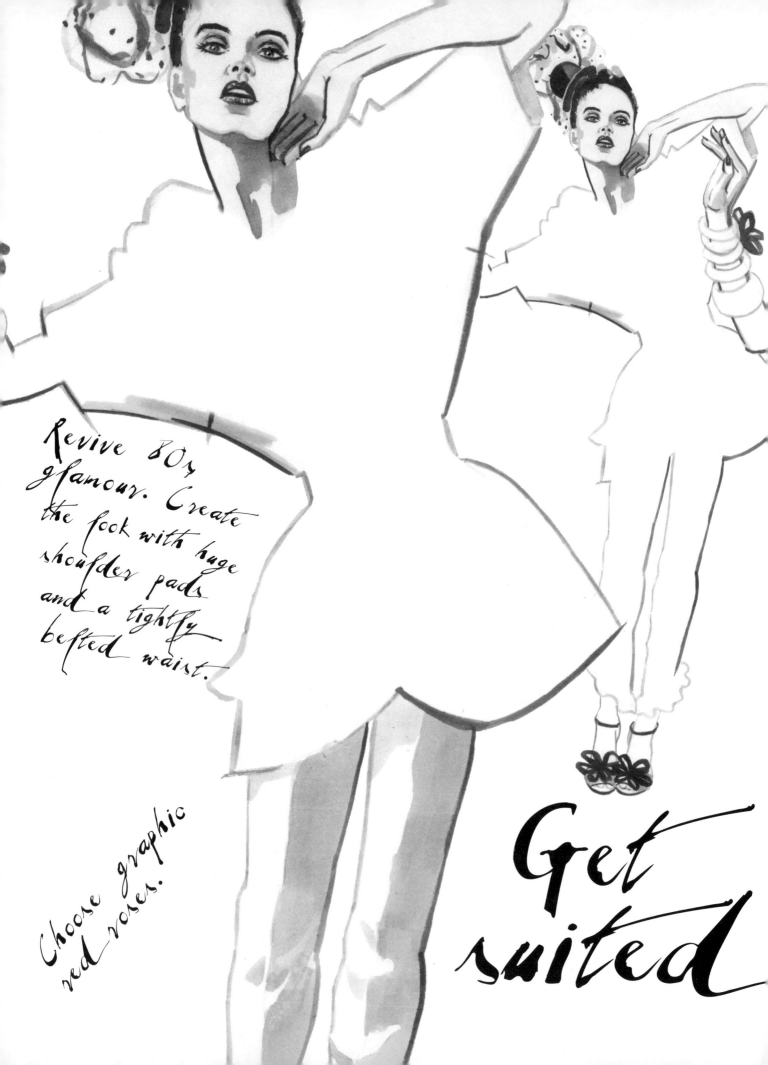

Revive 80s glamour. Create the look with huge shoulder pads and a tightly belted waist.

Choose graphic red roses.

Get suited

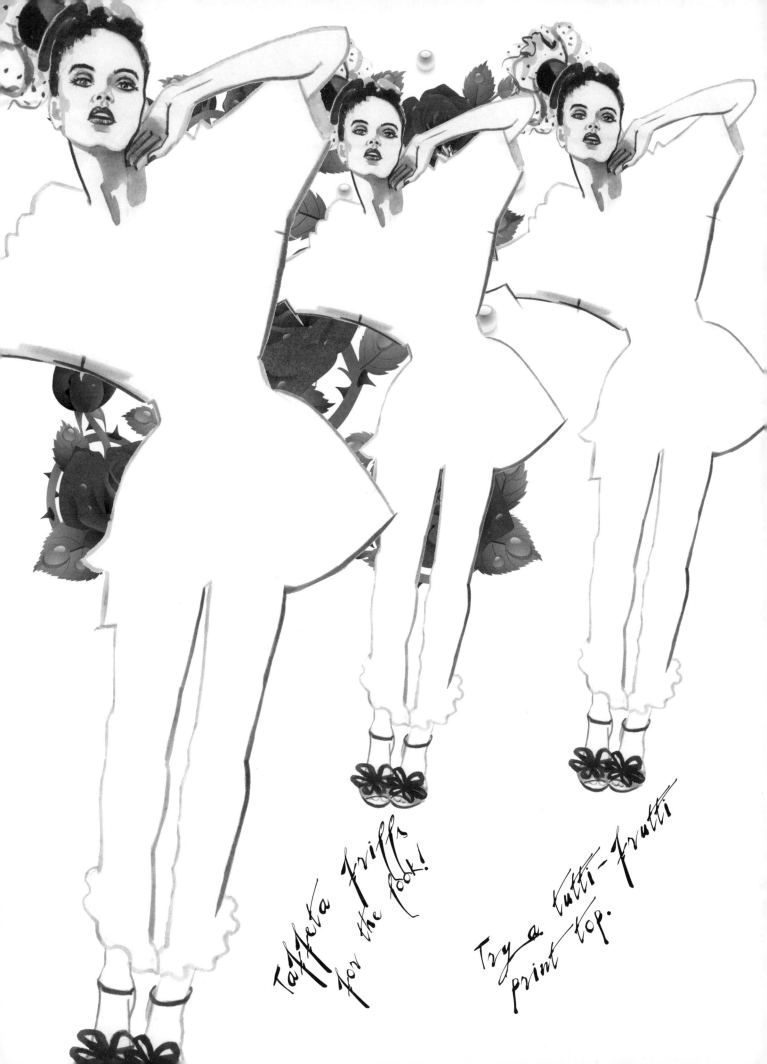

Taffeta frills
for the look!

Try a tutti-frutti
print top.

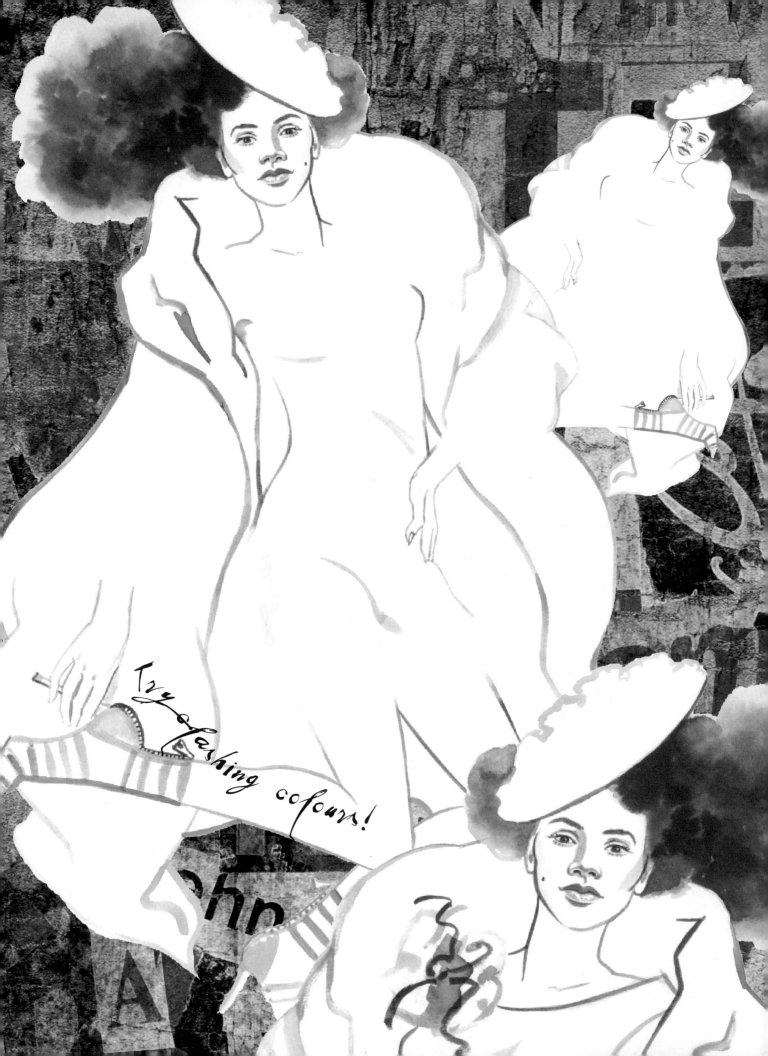

Try flashing colours!

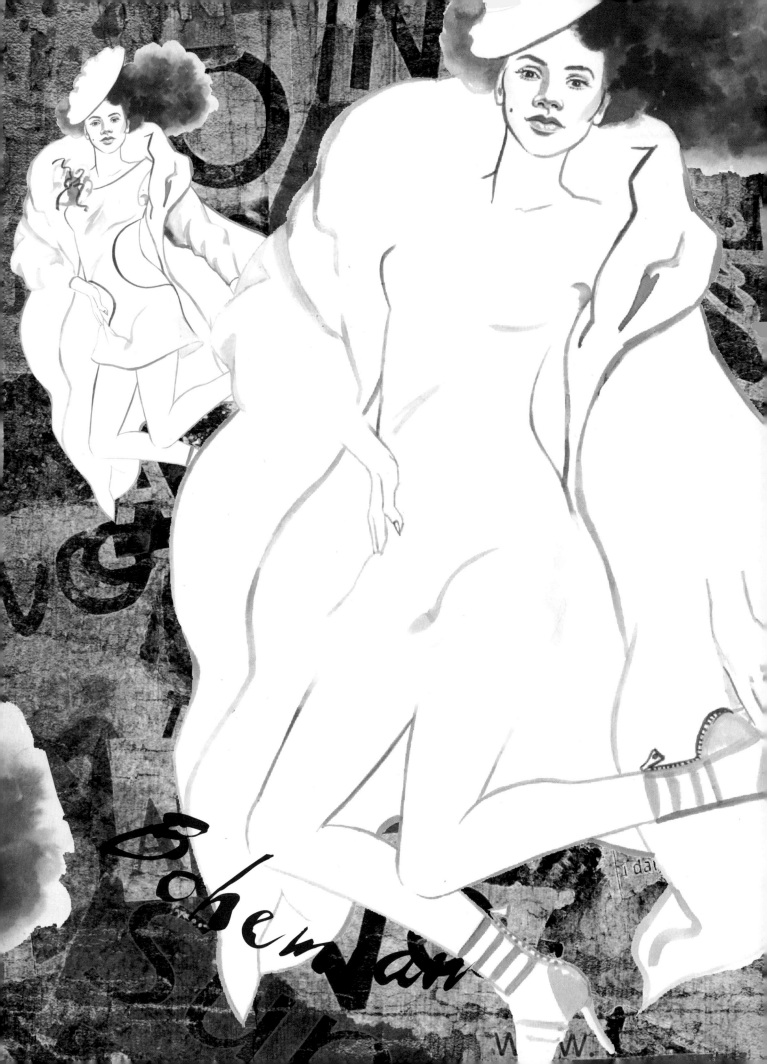

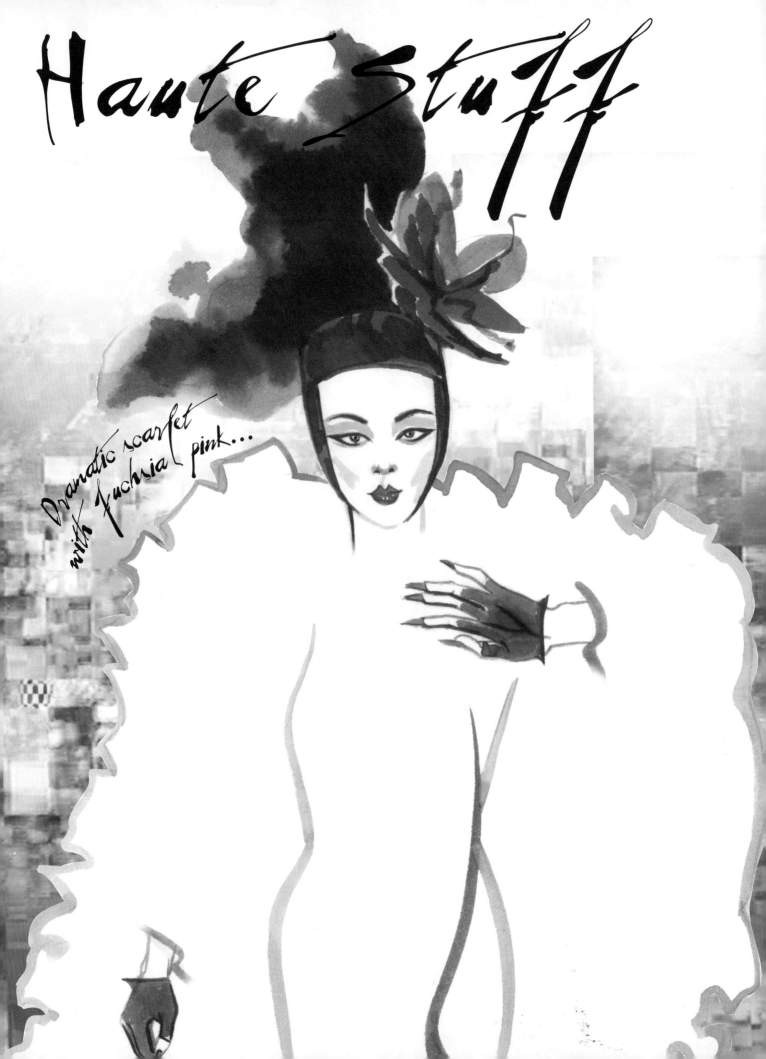

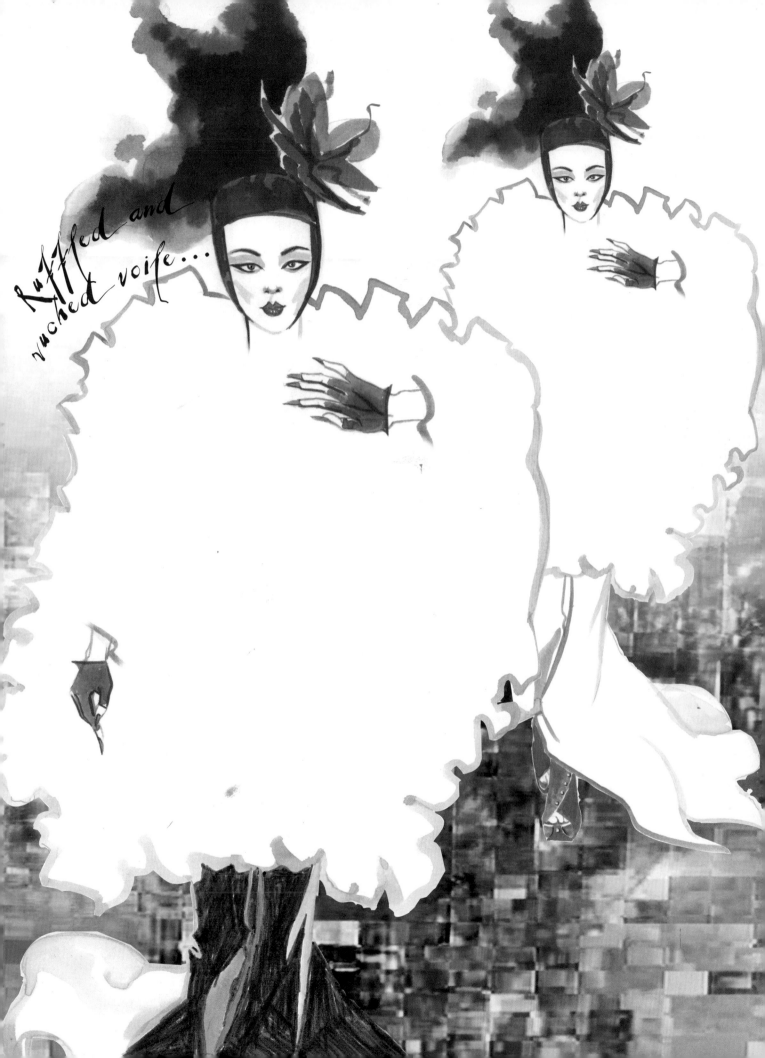

Ruffled and
ruched voile...

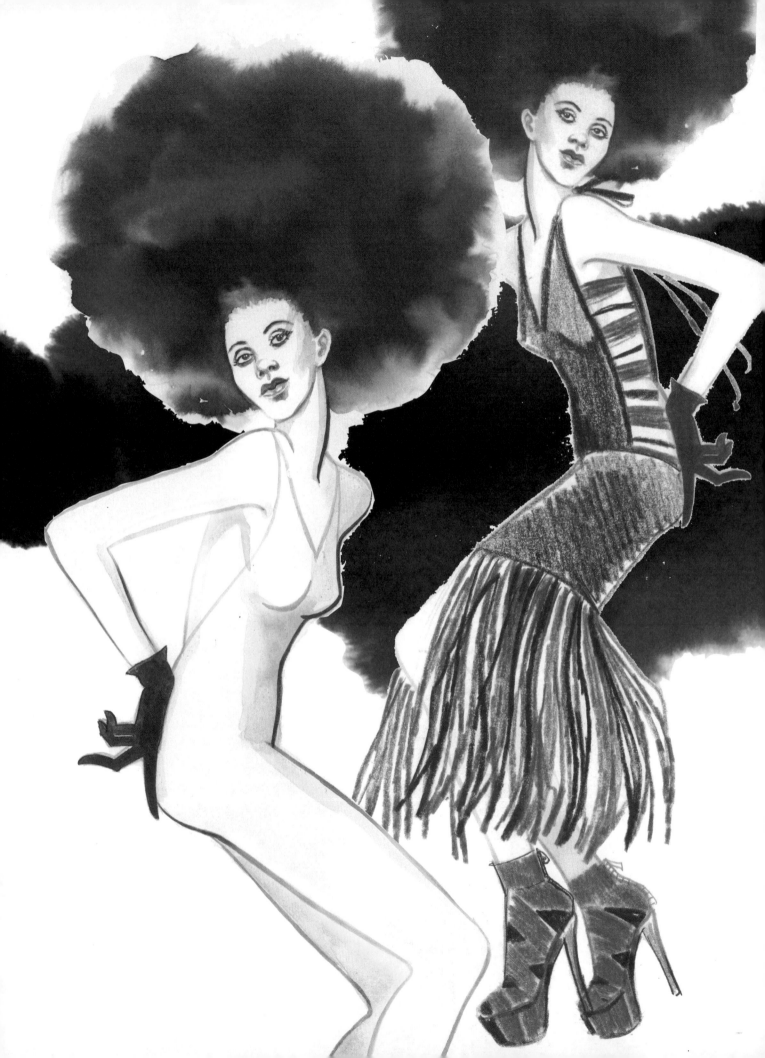

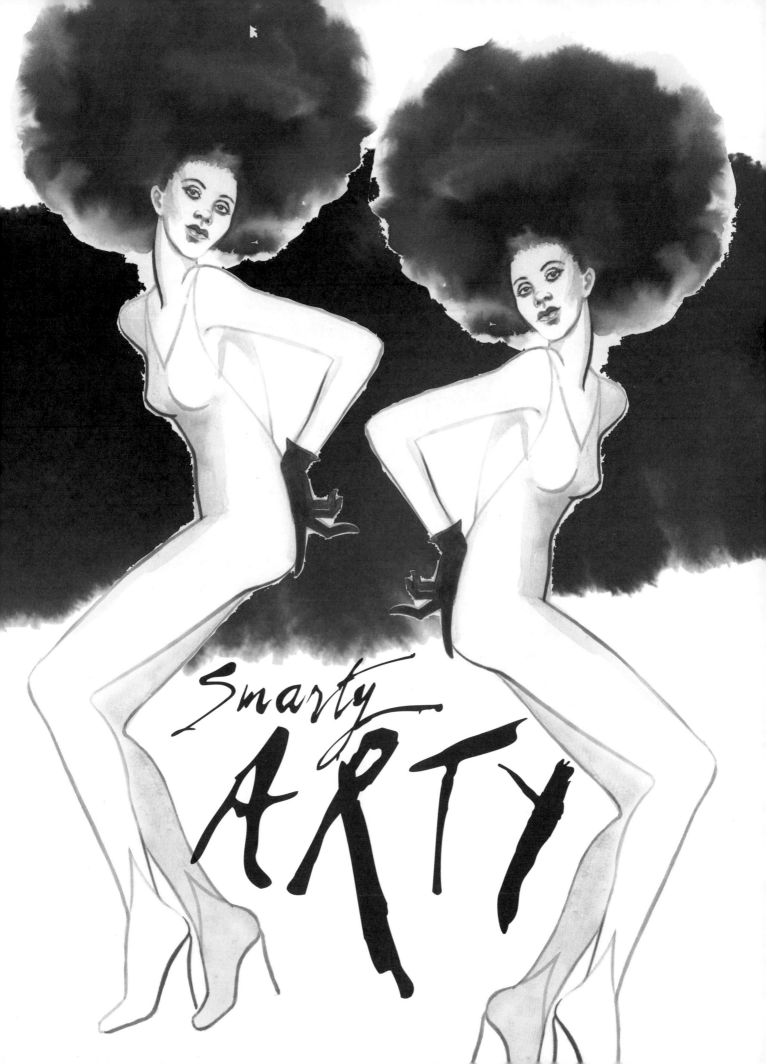

Colour: Rainbow
Theme: Paint drips

THE LOOK

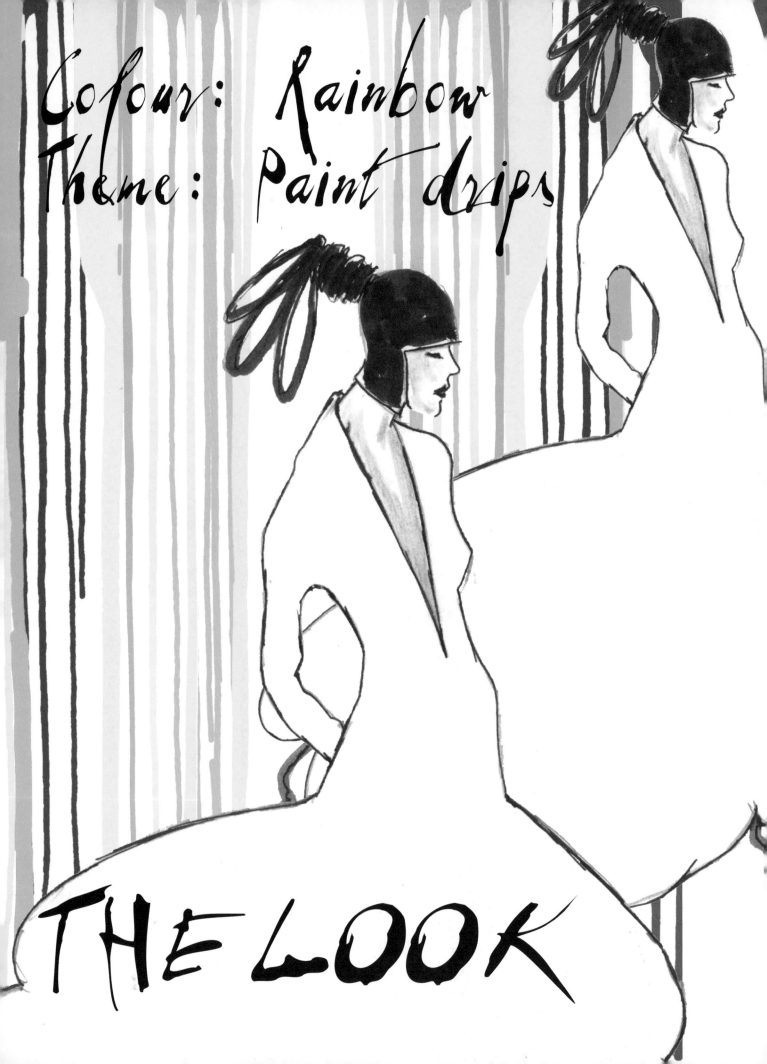

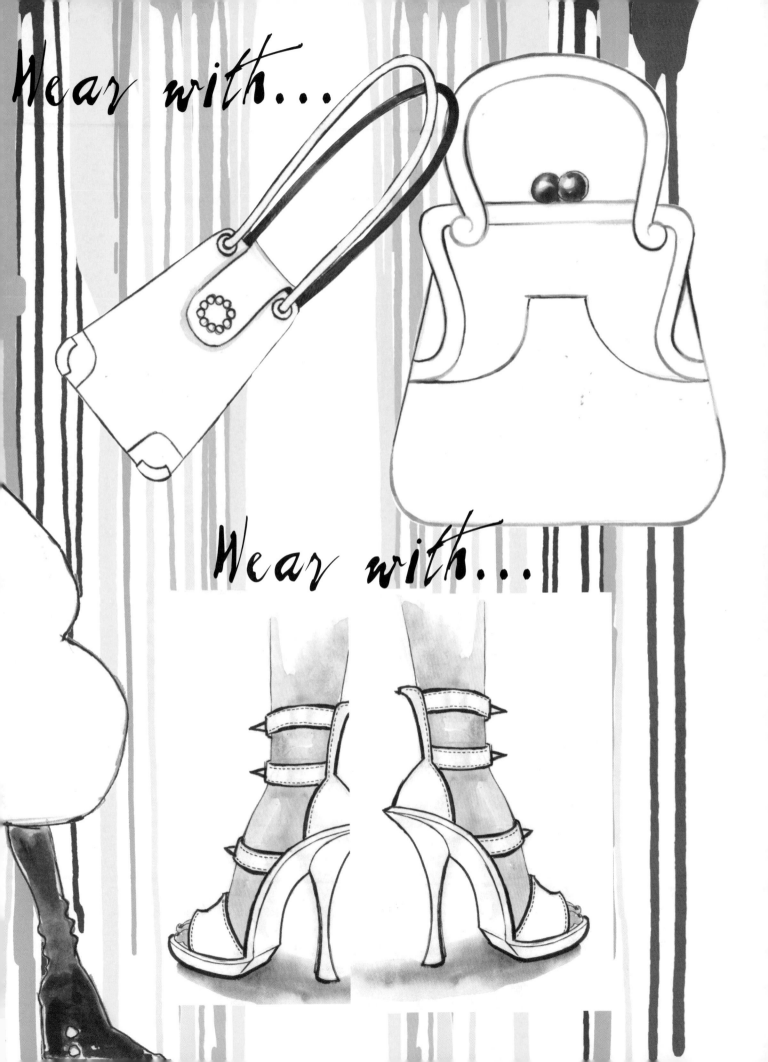

Wear with...

Wear with...

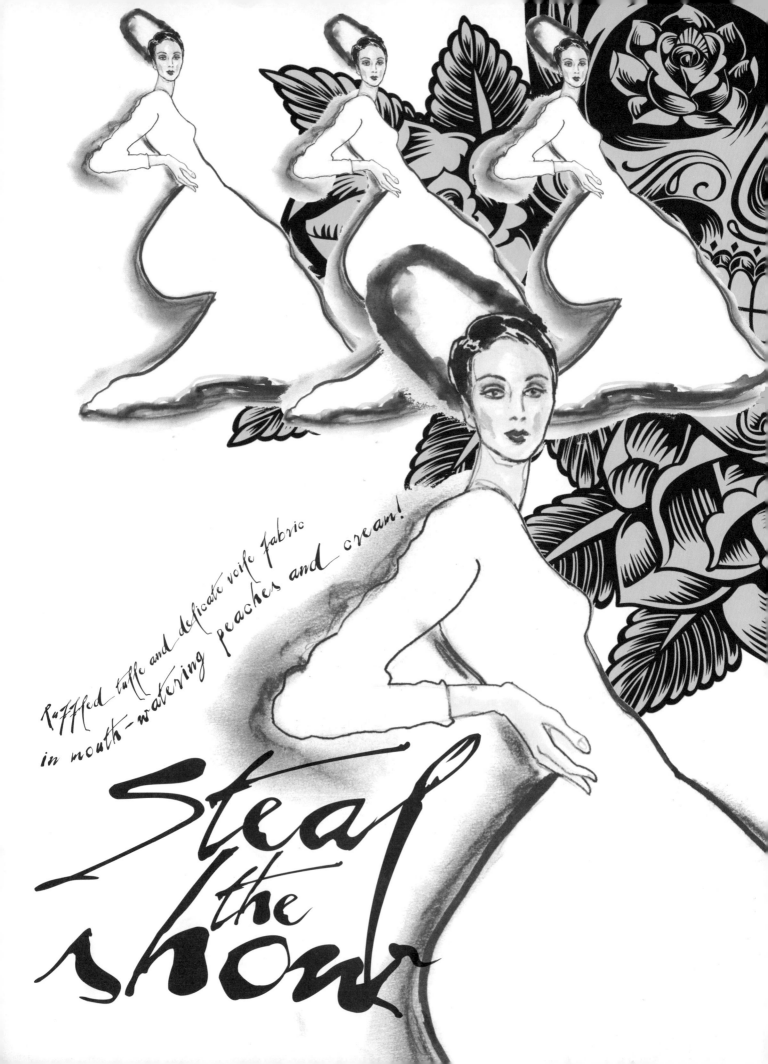

Ruffled tulle and delicate voile fabric in mouth-watering peaches and cream!

Steal the show

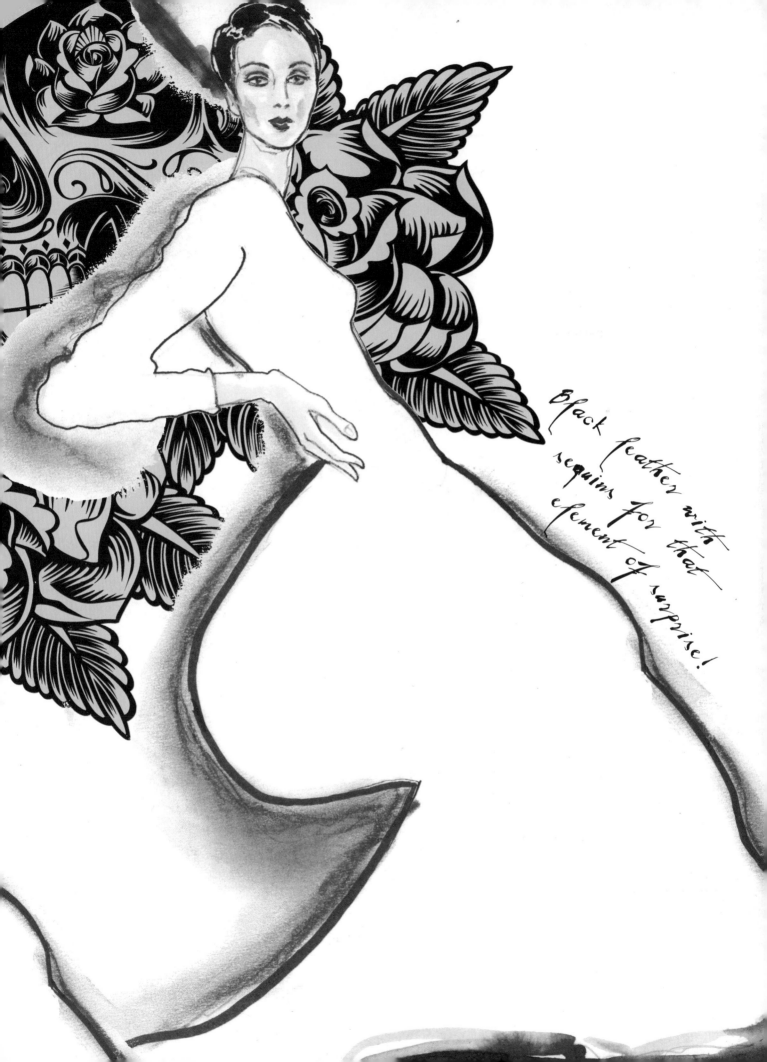

Black feather with sequins for that element of surprise!

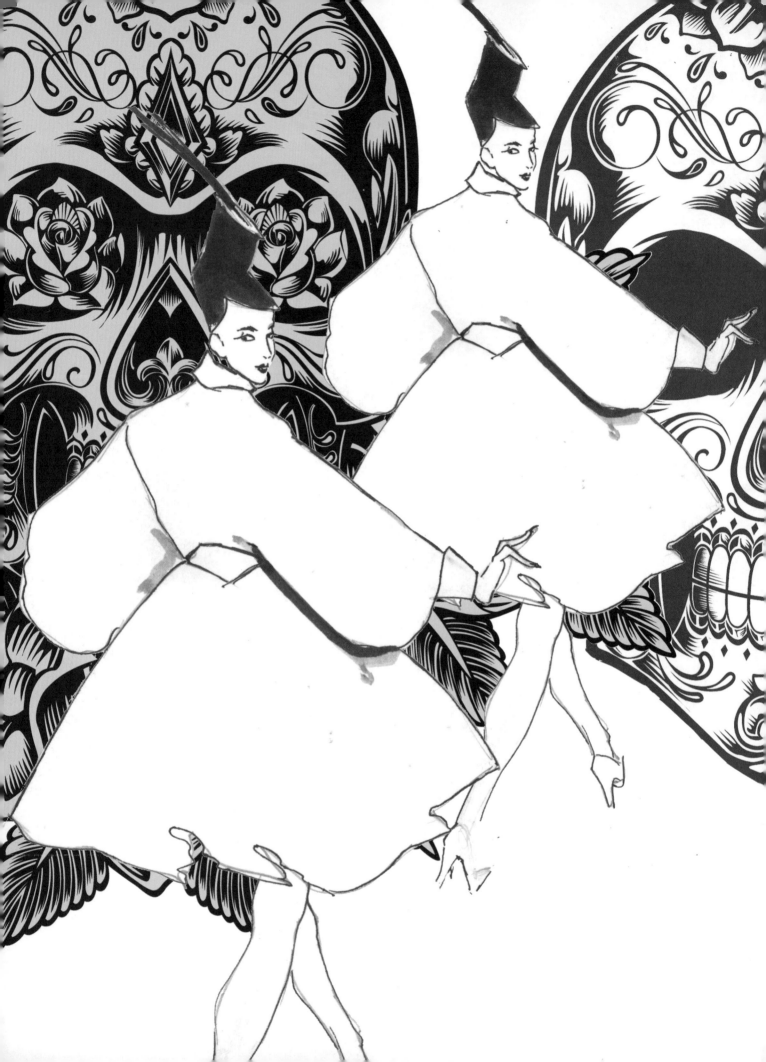

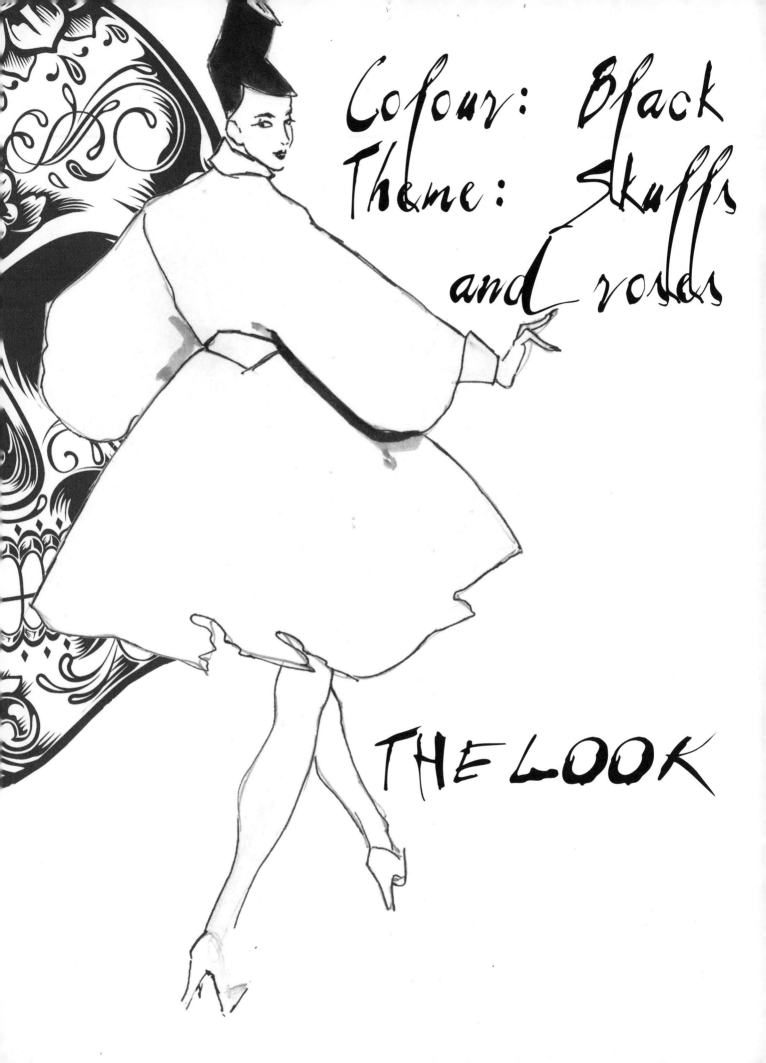

Colour: Black
Theme: Skulls
and roses

THE LOOK

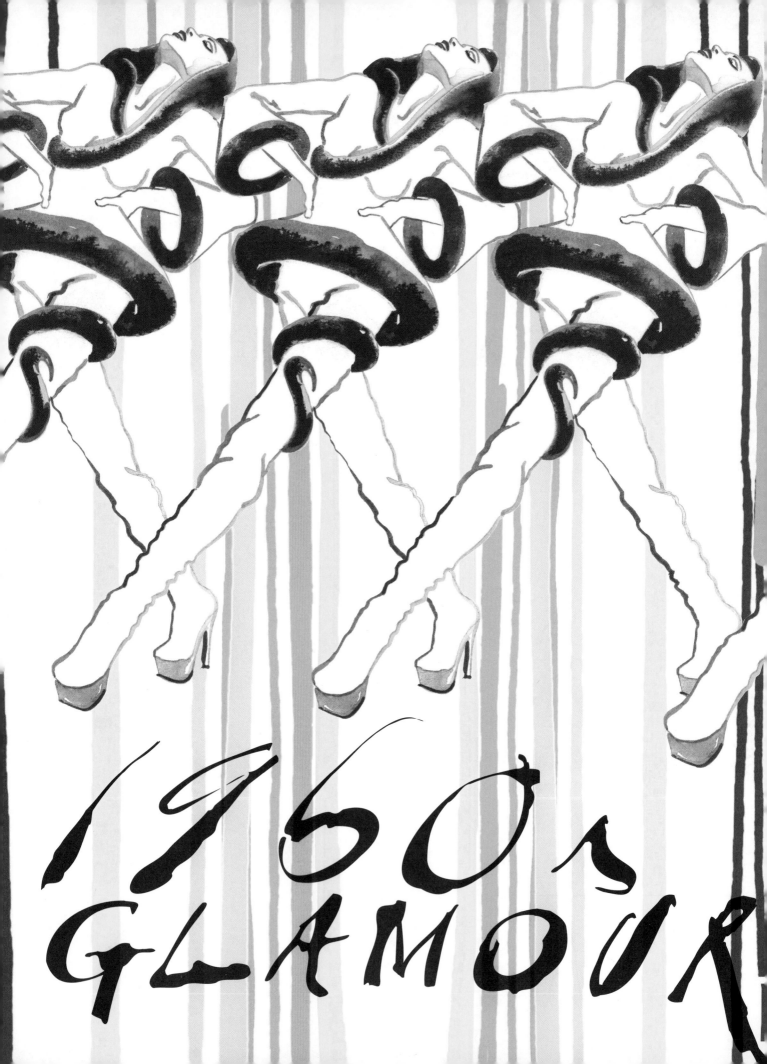

1950s GLAMOUR

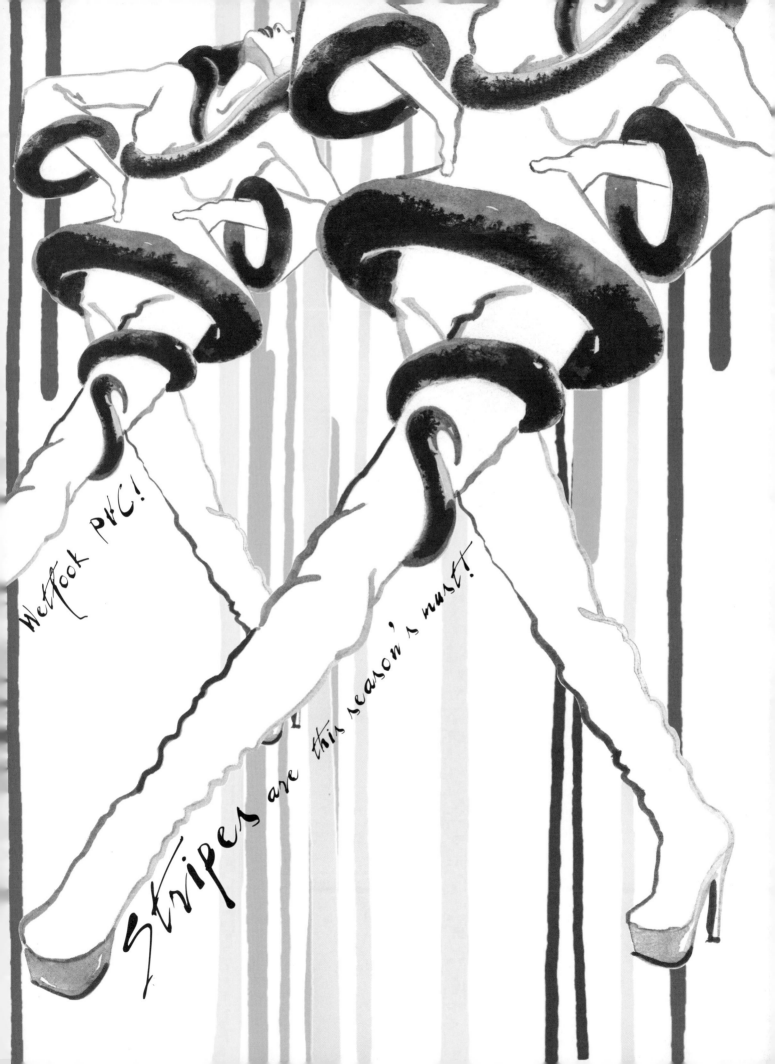

Wetlook PVC!

Stripes are this season's must!

Colour: Red
Theme: Roses

Wear with...

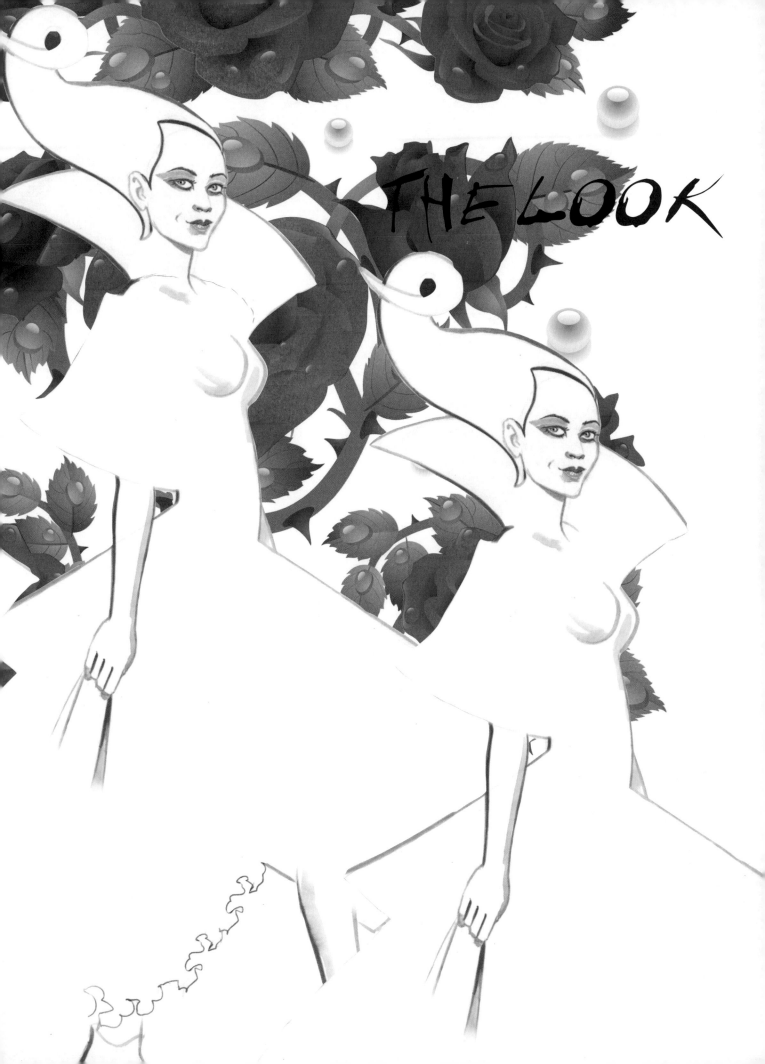

THE LOOK

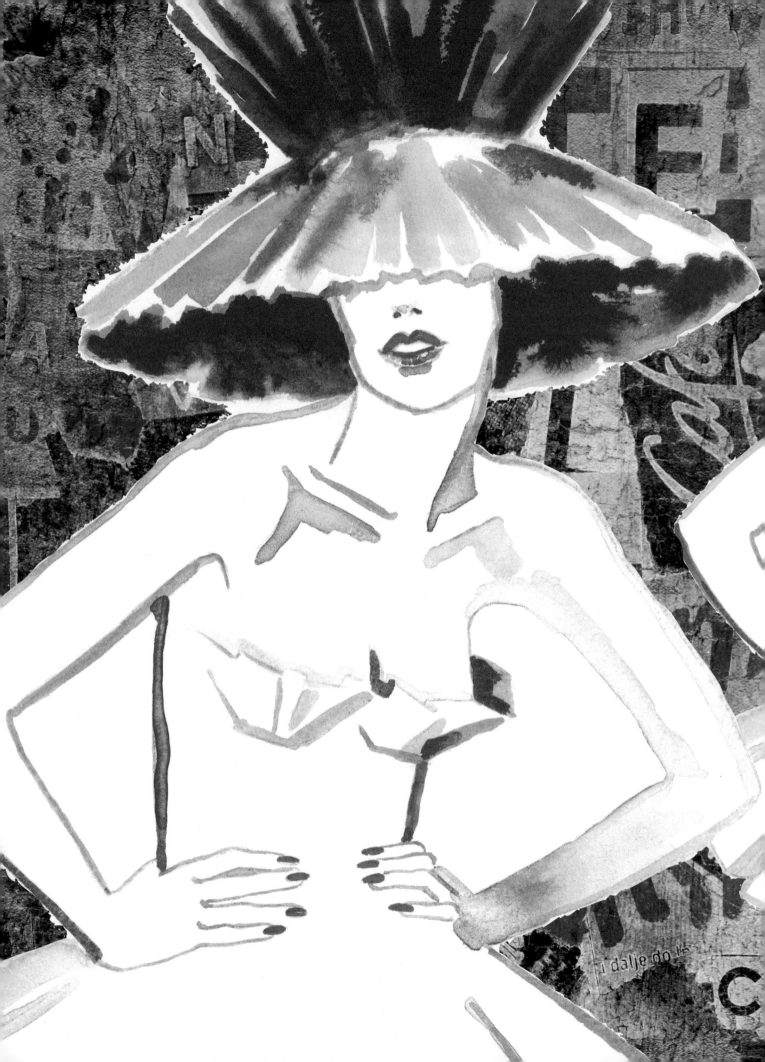

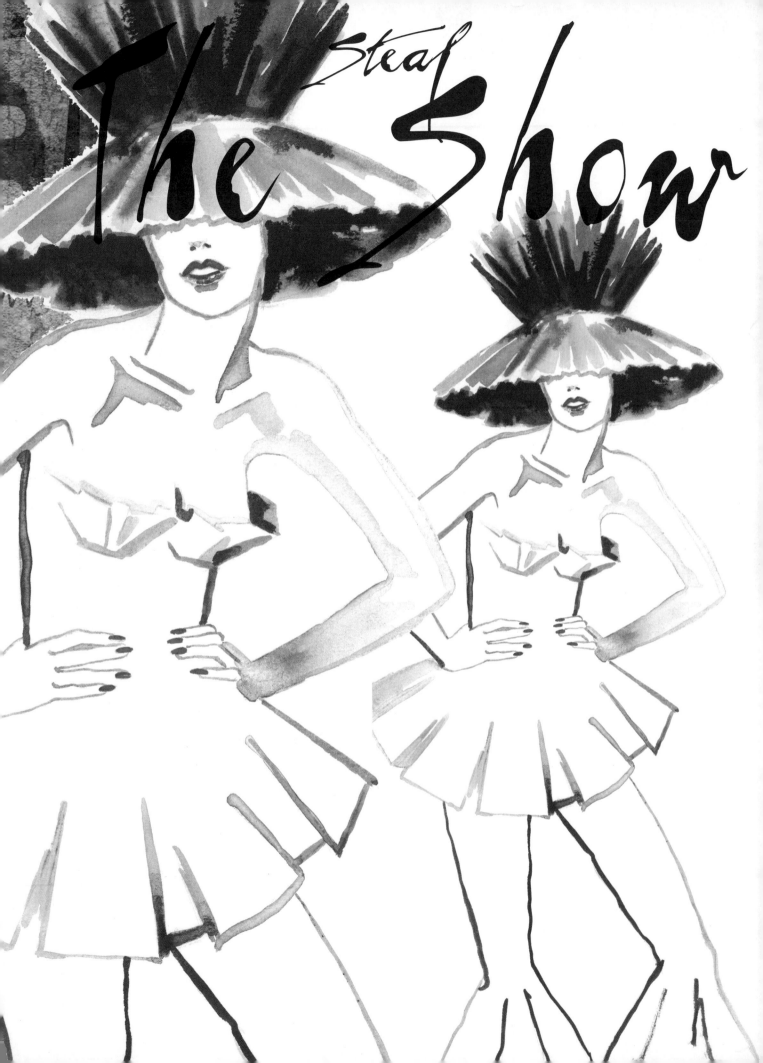

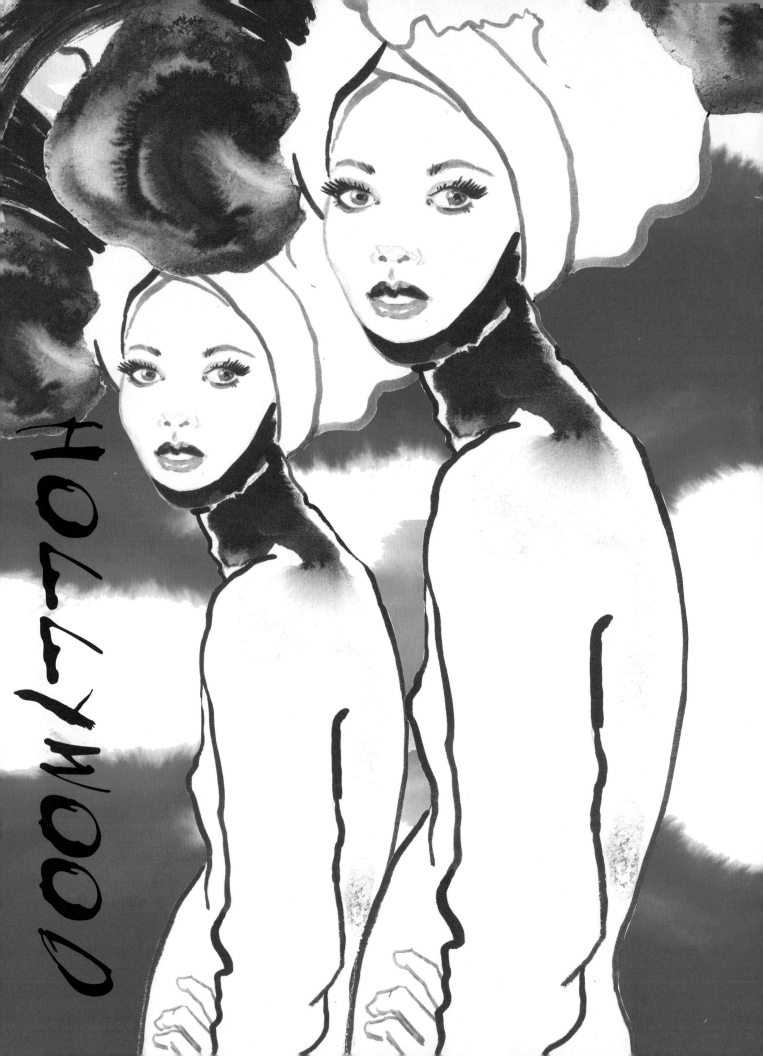